NORMAN ROCKWELL'S
Four Seasons

GEORGE MENDOZA

GROSSET & DUNLAP

PUBLISHERS • NEW YORK

Designed by Bernard Schleifer

FIRST PRINTING 1982

Library of Congress Catalog Card Number 82-82233

ISBN 0-448-16618-6

The sixty-eight Norman Rockwell Four Seasons illustrations, the "Come and Get It" illustration and "The Runaway" illustration are from the archives of Brown & Bigelow.

Saturday Evening Post illustrations reprinted with permission from The Curtis Publishing Company. © 1982 The Curtis Publishing Company.

For kind permission to reprint copyrighted material, grateful acknowledgment is made to the following sources. Any oversight is inadvertent and will be corrected on notification in writing to the Publisher.

Atheneum Publishers for "Winter's End" by Howard Moss, copyright 1954, 1982 by Howard Moss. In *Selected Poems*, copyright © 1971 by Howard Moss.

Doubleday & Company, Inc., for "Lightning at Night" and "The Way of Zen" by Matsuo Bashō, "Autumn" and "Springtime" by Raizan, "Coolness in Summer" by Ryusui, "Winter" by Shiki, and "The Seasons" by Sanpu from *An Introduction to Haiku* translated by Harold G. Henderson, copyright © 1958 by Harold G. Henderson; and for selections from *The Mist Men and Other Poems* by George Mendoza, copyright © 1970 by George Mendoza.

Doubleday & Company, Inc., A. P. Watt, Ltd., and The National Trust for Places of Historic Interest or Natural Beauty for "The Way Through the Woods" by Rudyard Kipling, copyright 1910 by Rudyard Kipling, from *Rudyard Kipling's Verse: Definitive Edition*.

Robert Graves for "Allie" by Robert Graves, from *Collected Poems* by Robert Graves.

Harcourt Brace Jovanovich, Inc., for "Elm Buds" by Carl Sandburg. From *Honey and Salt*, copyright © 1963 by Carl Sandburg.

Harcourt Brace Jovanovich, Inc., and Faber and Faber Publishers for "Year's End" by Richard Wilbur, copyright 1949, © 1977 by Richard Wilbur. From *Poems 1943–1956* and from *Ceremony and Other Poems* by Richard Wilbur. First published in *The New Yorker*.

Harvard University Press and the Trustees of Amherst College for "Have you got a brook . . . ," "The Snow" and "The Train" by Emily Dickinson, from *The Poems of Emily Dickinson*, edited by Thomas H. Johnson. Cambridge: Harvard University Press. Copyright 1951, 1955, © 1979 by the President and Fellows of Harvard College.

Holt, Rinehart and Winston and Jonathan Cape Ltd. for "Dust of Snow," "My November Guest," "October," "A Prayer in Spring" and "Stopping by Woods on a Snowy Evening" by Robert Frost, from *The Poetry of Robert Frost*, edited by Edward Connery Lathem. Copyright 1923, 1934, © 1969 by Holt, Rinehart and Winston. Copyright 1951, © 1962 by Robert Frost.

Holt, Rinehart and Winston, The Society of Authors, and Jonathan Cape Ltd. for "Loveliest of trees, the cherry now" by A. E. Housman. From "A Shropshire Lad"—Authorised Edition—from *The Collected Poems of A. E. Housman*. Copyright 1939, 1940, © 1965 by Holt, Rinehart and Winston. Copyright © 1967, 1968 by Robert E. Symons.

Alfred A. Knopf, Inc., for "Velvet Shoes" by Elinor Wylie, reprinted from *Collected Poems of Elinor Wylie*, copyright 1921 by Alfred A. Knopf, Inc., and renewed 1949 by William Rose Benet.

Alfred A. Knopf, Inc., and Faber and Faber Publishers for "The Snow Man" by Wallace Stevens, reprinted from *The Collected Poems of Wallace Stevens*, copyright 1923 and renewed 1951 by Wallace Stevens.

Liveright Publishing Corporation and Granada Publishing Limited for "In Just-" and "Spring is like a perhaps hand" by e. e. cummings, from *Tulips & Chimneys* by e. e. cummings. Copyright 1923, 1925 and renewed 1951, 1953 by e. e. cummings. Copyright © 1973, 1976 by the Trustees for the e. e. cummings Trust. Copyright © 1973, 1976 by George James Firmage.

Macmillan Publishing Co., Inc., for "Leaves" by Sara Teasdale, from *Collected Poems* by Sara Teasdale, copyright 1915 by Macmillan Publishing Co., Inc., renewed 1943 by Mamie T. Wheless.

Random House, Inc., and Martin Secker & Warburg Ltd. for "Something Is Going to Happen" by Robert Penn Warren, copyright © 1963 by Robert Penn Warren. Reprinted from *Selected Poems 1923–1975* by Robert Penn Warren.

Viking Penguin Inc. for "Vermont: Indian Summer" from *Letter From a Distant Land* by Philip Booth. Copyright 1953 by Philip Booth. Originally published in *The New Yorker*.

Wesleyan University Press and Jonathan Cape Ltd. for "Leisure" by William Henry Davies, copyright © 1963 by Jonathan Cape Ltd. Reprinted from *The Complete Poems of William Henry Davies*.

ACKNOWLEDGMENTS

AND WITH SPECIAL THANKS to all those who helped in the production of this book: Seth Huntington, Creative Director, Brown & Bigelow; Don Benson, Vice President, Brown & Bigelow; Ron McIntyre, President, Licensing Division, The Curtis Publishing Company; Paul S. Petticrew, Director of Licensing and Royalties, The Curtis Publishing Company; Mary Beth Vahle, Jeanine Quelch, of The Curtis Publishing Company; Mike Cohn; Norma Anderson and Louise Bates; Nancy Perlman and Gypsy da Silva of The Putnam Publishing Group; and Bernie Schleifer, designer. Finally, my deepest gratitude to my sister, Elise, and her husband, Richard Curry, who were very generous to the author in their research and shaping of this book.

THIS BOOK IS tenderly dedicated to

my old friend Israel Kalish,

who believes in dreams,

and to Peter Israel,

who was there to save them.

NORMAN ROCKWELL'S

Four Seasons

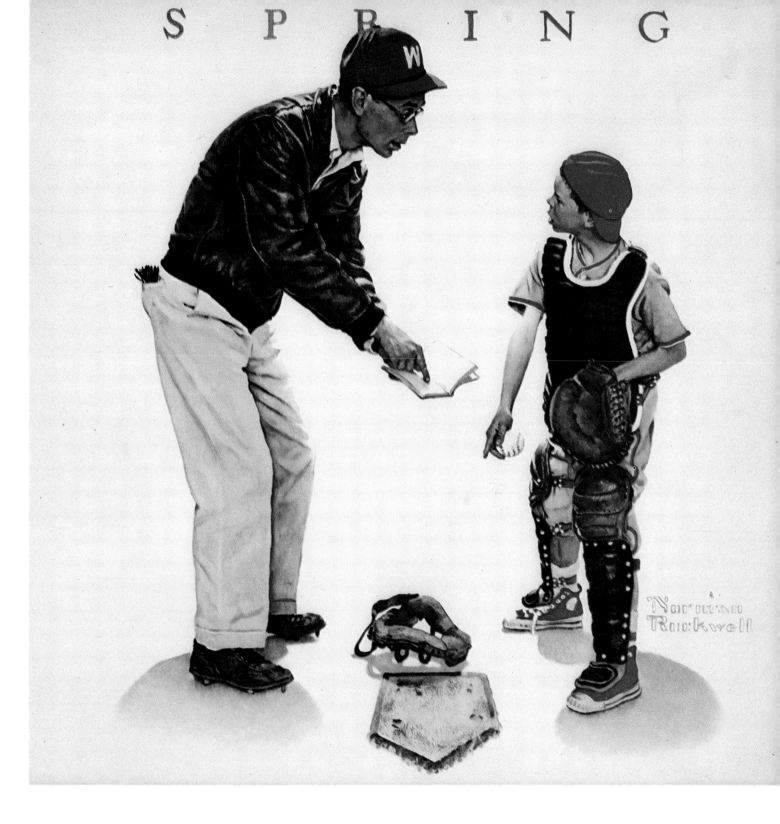

Gathering, gathering—
and then throwing them away:
grasses in the spring.

—RAIZAN
"Springtime"

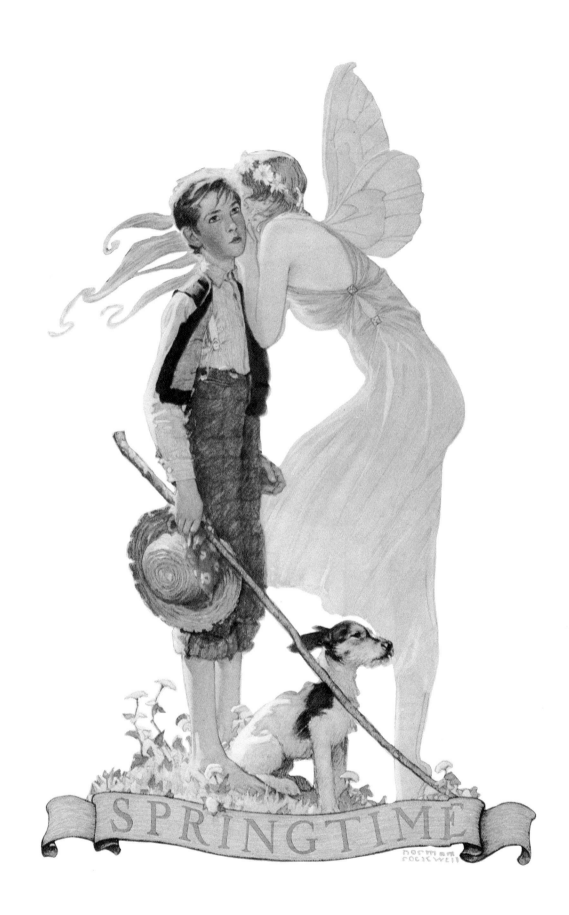

I dream under banks of dreams;
by deep pool beds I'll lay my head
and let my dreams flow between mountains,
past springs nippling under fern,
till darkness presses darkness,
and all the night
is a river to the stars.

—GEORGE MENDOZA

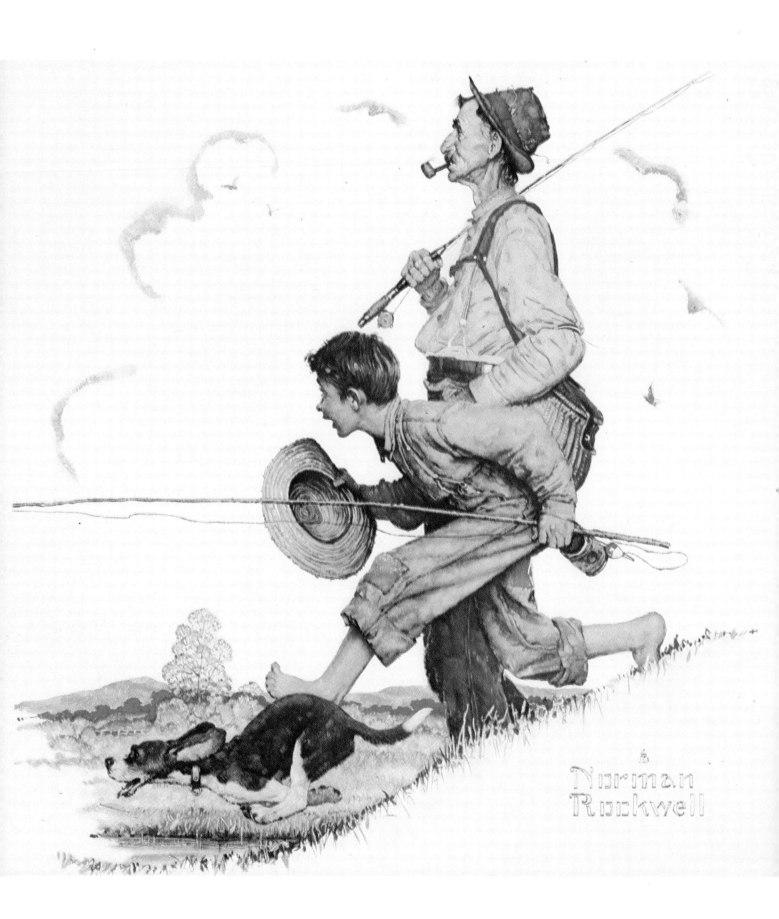

This is where I go,
 down the rapid flashing stretch,
 into the winding swirl of stream
where the world wheels on a spool of dreams
and shadows are flowers that never stop
 opening
and clouds sail out of shells of clouds
and rainbows are the colors of butterfly
 wings.

—*GEORGE MENDOZA*

Are grasses exclamation points
and stones periods?
Are birds grammarians
when they peck with their beaks?
Oh, look to wild weeds
and see how lovely they grow.

—*GEORGE MENDOZA*

If ever I saw blessing in the air
 I see it now in this still early day
Where lemon-green the vaporous morning
 drips
 Wet sunlight on the powder of my eye.

Blown bubble-film of blue, the sky wraps
 round
 Weeds of warm light whose every root and
 rod
Splutters with soapy green, and all the world
 Sweats with the bead of summer in its bud.

If ever I heard blessing it is there
 Where birds in trees that shoals and
 shadows are
Splash with their hidden wings and drops of
 sound
 Break on my ears their crests of throbbing
 air.

Pure in the haze the emerald sun dilates,
 The lips of sparrows milk the mossy stones,
While white as water by the lake a girl
 Swims her green hand among the gathered
 swans.

Now, as the almond burns its smoking wick,
 Dropping small flames to light the candled
 grass;
Now, as my low blood scales its second
 chance,
 If ever world were blessed, now it is.

—LAURIE LEE
"April Rise"

I'm a man with an itch
not in my heart
but in my feet.
When I'm hucking in Vermont
stuffing leaves in my pocket
tying flies to my leader
in the beam of my *Eveready* in the dark
I'm thinking too soon of the city.
When I'm too long in the city
I'm hucking to get back to Vermont . . .
 to Vermont . . .
stuffing leaves in my pocket
tying flies to my leader
listening to the swish of my rod in the dark.
I'm a man with an itch
with both feet in my heart.

—GEORGE MENDOZA

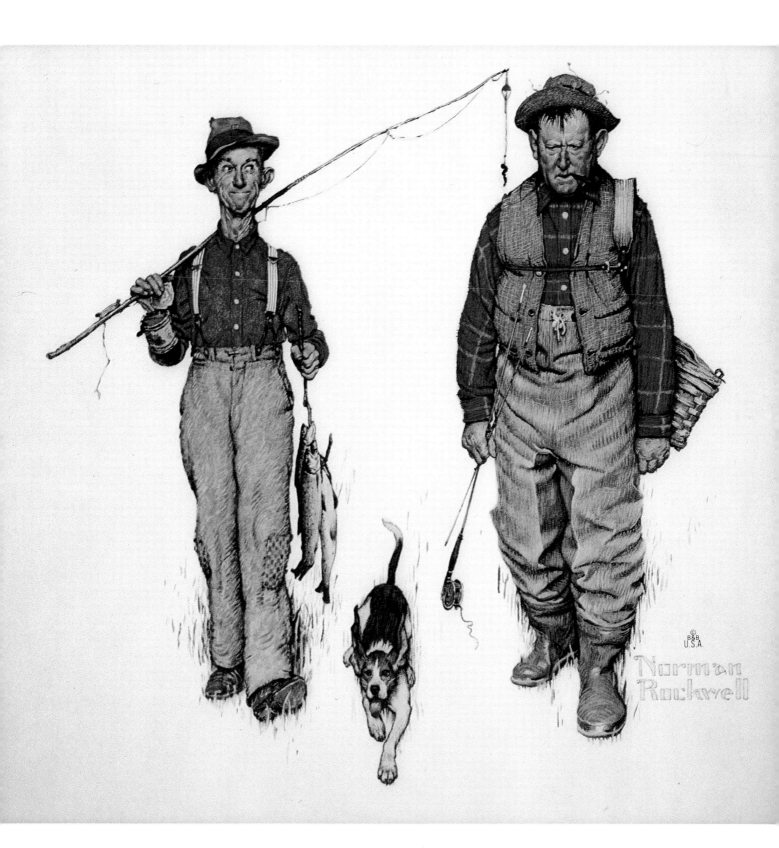

The Cock is crowing,
The stream is flowing,
The small birds twitter,
The lake doth glitter,
The green field sleeps in the sun;
The oldest and youngest
Are at work with the strongest;
The cattle are grazing,
Their heads never raising;
There are forty feeding like one!
Like an army defeated
The snow hath retreated,
And now doth fare ill
On the top of the bare hill;
The ploughboy is whooping—anon—anon:
There's joy in the mountains;
There's life in the fountains;
Small clouds are sailing,
Blue sky prevailing;
The rain is over and gone!

—WILLIAM WORDSWORTH
"Written in March"

Another hundred years and the river
will be gone:
stones will look like cattle skulls,
bones of birch will worm the sky,
banks cool in waves of fern
no poet will come to find.
Minnows will not fill the dreams
of a little boy's tobacco can.
Once-vermilion pools of trout,
will lie grave-under,
a wider road to travel on.

—GEORGE MENDOZA

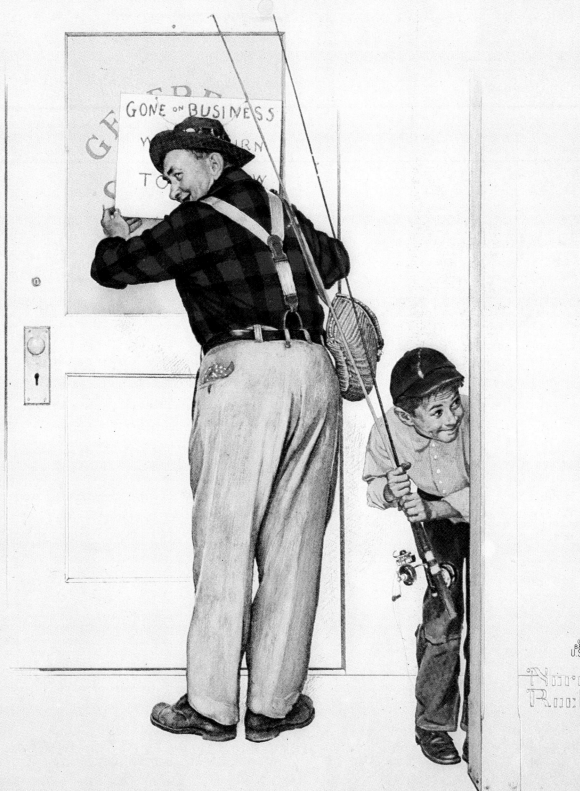

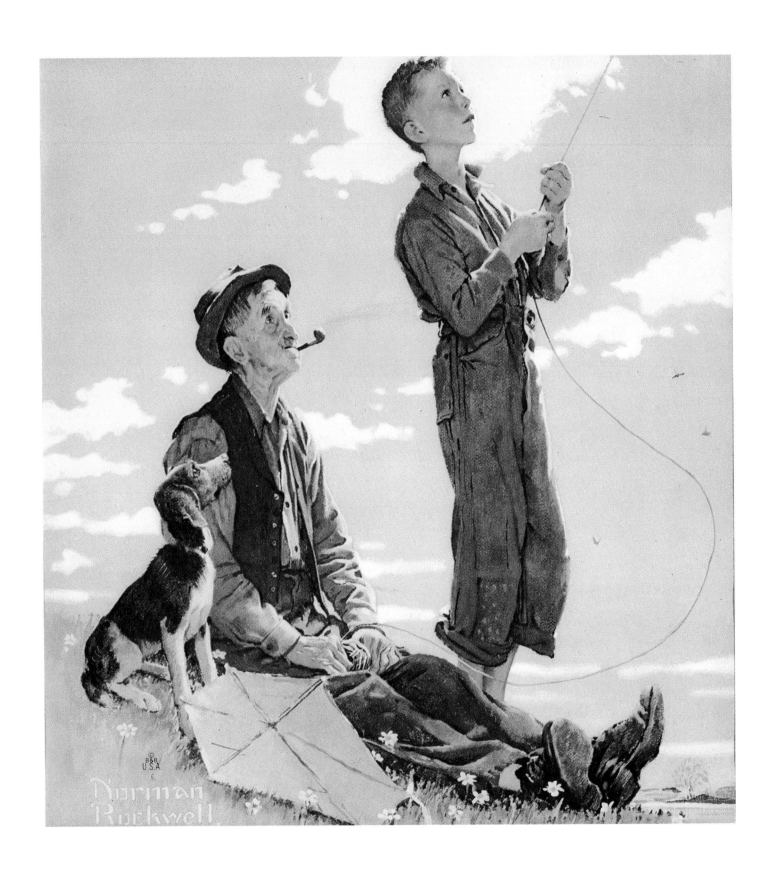

The bat went wheeing under the bridge,
up stream, down stream,
back and forth.
It was dark;
I couldn't see the water,
I couldn't see the rocks,
I couldn't see my line
swishing back and forth;
was the bat fishing for me?

—GEORGE MENDOZA

I hear splashing
 under a tree.
 Trout rolls over
like a crescent moon
in the water dark.
If you see my eyes
by a river bank
I have come asearching
like a gypsy boy.

<div style="text-align:right">—GEORGE MENDOZA</div>

A thing of beauty is a joy for ever:
Its loveliness increases; it will never
Pass into nothingness; but still will keep
A bower quiet for us, and a sleep
Full of sweet dreams, and health, and quiet
 breathing.

<div style="text-align:right">—JOHN KEATS
from "A Thing of Beauty"</div>

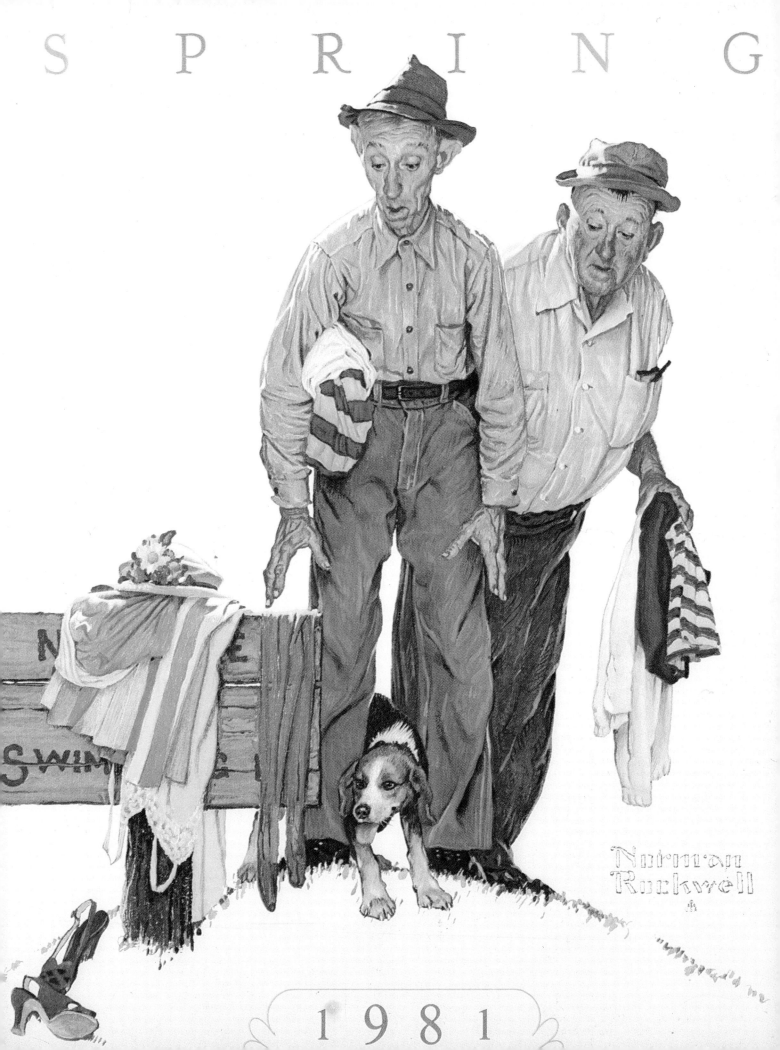

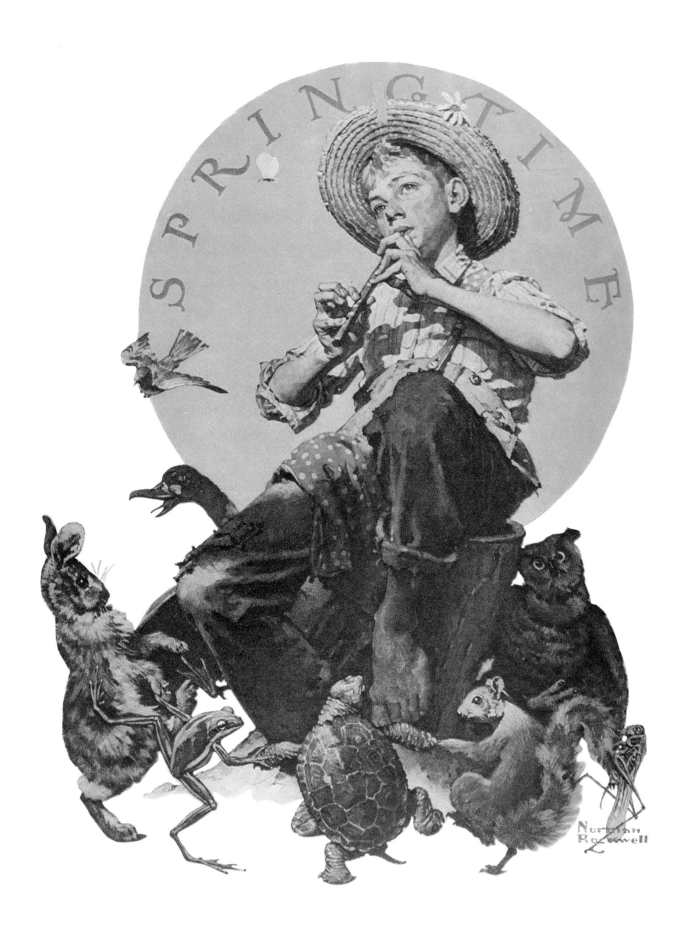

Used to see cut out shapes
up there all the time
faces with puffy noses
and rushing blue through
eyes,
and chins that jutted out
like mountain peaks,
up there faces rode the sky
like children mad
on a coaster ride.

Once I saw a flower maiden
looking down at me.
Her face of clouds
has never left my eyes.
Perhaps she wondered where I went
when, alas, the light of day was gone.

—GEORGE MENDOZA
"Faces on the edges of clouds"

May! queen of blossoms,
 And fulfilling flowers,
With what pretty music
 Shall we charm the hours?
Wilt thou have pipe and reed,
Blown in the open mead?
Or to the lute give heed
 In the green bowers?

Thou hast no need of us,
 Or pipe or wire;
Thou hast the golden bee
 Ripen'd with fire;
And many thousand more
Songsters, that thee adore,
Filling earth's grassy floor
 With new desire.

Thou hast thy mighty herds,
 Tame and free-livers;
Doubt not, thy music too
 In the deep rivers;

And the whole plumy flight
Warbling the day and night—
Up at the gates of light,
 See, the lark quivers!

—EDWARD, LORD THURLOW
"May"

Allie, call the birds in,
 The birds from the sky!
Allie calls, Allie sings,
 Down they all fly:
First there came
Two white doves,
 Then a sparrow from his nest,
Then a clucking bantam hen,
 Then a robin red-breast.

Allie, call the beasts in,
 The beasts, every one!
Allie calls, Allie sings,
 In they all run:
First there came
Two black lambs,
 Then a grunting Berkshire sow,
Then a dog without a tail,
 Then a red and white cow.

Allie, call the fish up,
 The fish from the stream!
Allie calls, Allie sings,
 Up they all swim:
First there came
Two gold fish,
 A minnow and a miller's thumb,
Then a school of little trout,
 Then the twisting eels come.

Allie, call the children,
 Call them from the green!
Allie calls, Allie sings,
 Soon they run in:
First there came
Tom and Madge,
 Kate and I who'll not forget
How we played by the water's edge
 Till the April sun set.

—ROBERT GRAVES
"Allie"

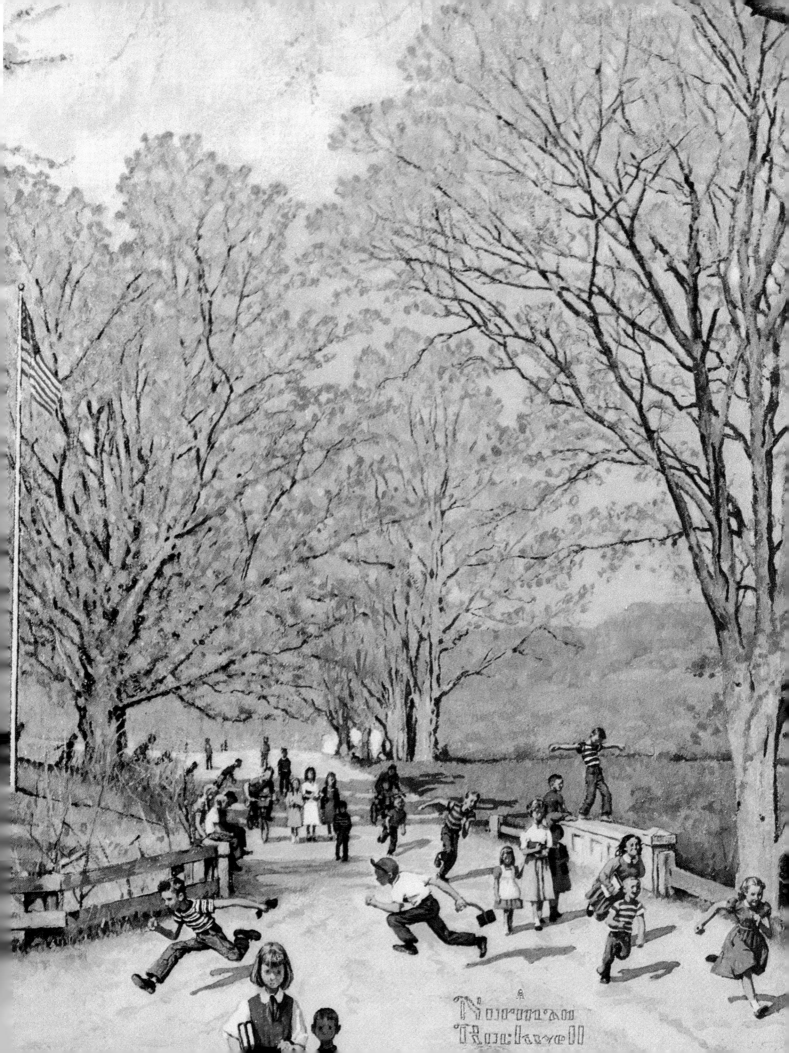

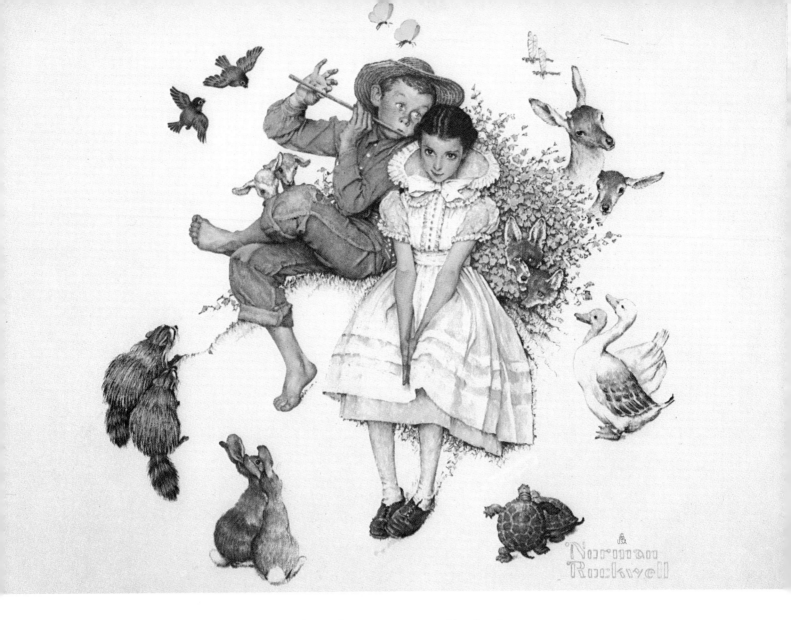

O thou with dewy locks, who lookest down
Through the clear windows of the morning, turn
Thine angel eyes upon our western isle,
Which in full choir hails thy approach, O Spring!

The hills tell one another, and the listening
Valleys hear; all our longing eyes are turn'd
Up to thy bright pavilions: issue forth
And let thy holy feet visit our clime!

Come o'er the eastern hills, and let our winds
Kiss thy perfumèd garments; let us taste
Thy morn and evening breath; scatter thy pearls
Upon our lovesick land that mourns for thee.

O deck her forth with thy fair fingers; pour
Thy soft kisses on her bosom; and put
Thy golden crown upon her languish'd head,
Whose modest tresses are bound up for thee.

—WILLIAM BLAKE
"To Spring"

Elm buds are out.
Yesterday morning, last night,
 they crept out.
They are the mice of early
 spring air.

To the north is the gray sky.
Winter hung it gray for the gray
 elm to stand dark against.
Now the branches all end with the
 yellow and gold mice of early
 spring air.
They are moving mice creeping out
 with leaf and leaf.

—CARL SANDBURG
"Elm Buds"

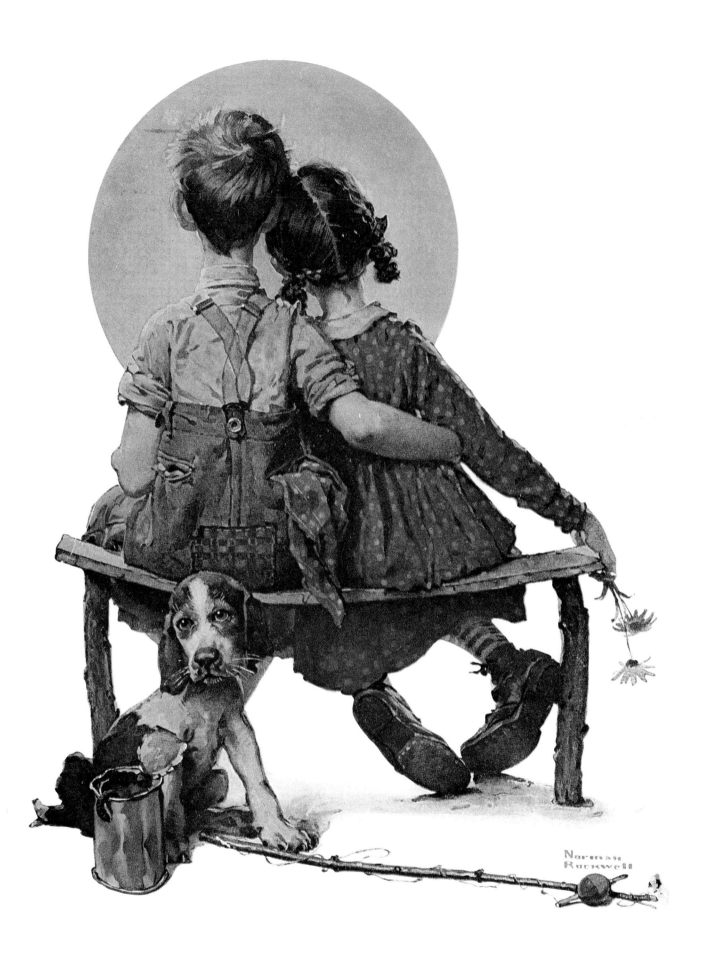

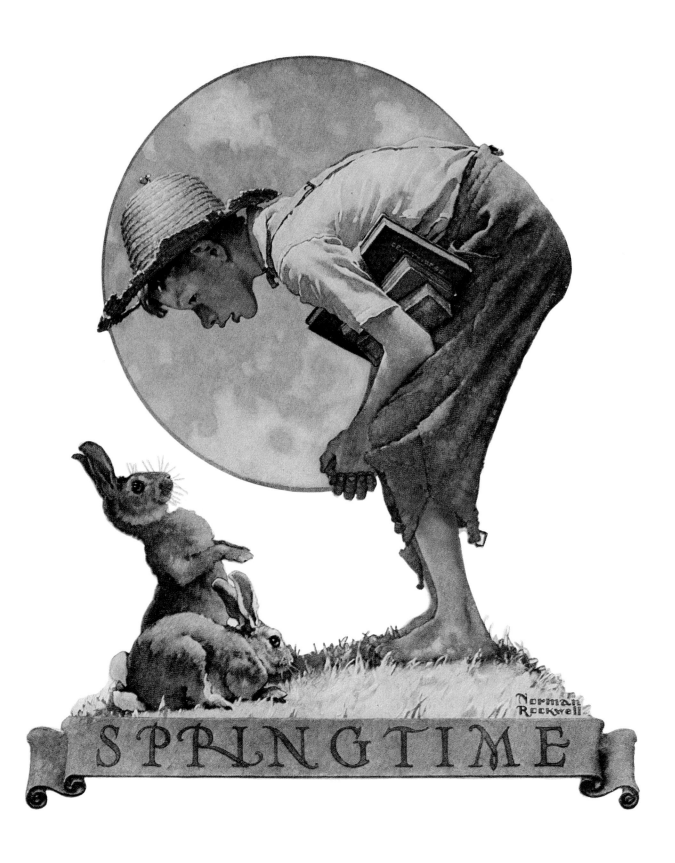

SPRINGTIME

in Just-
spring when the world is mud-
luscious the little
lame balloonman

whistles far and wee

and eddieandbill come
running from marbles and
piracies and it's
spring

when the world is puddle-wonderful

the queer
old balloonman whistles
far and wee
and bettyandisbel come dancing

from hop-scotch and jump-rope and

it's
spring
and
 the
 goat-footed
balloonMan whistles
far
and
wee

—*e. e. cummings*
"in Just-spring"

Spring snow
 sweeps past my windows,
 last of it, I pray,
for winter has been long and hard.
How I yearn for Spring.
To see flowers flowing over fields,
to hear streams gurgling with trout.
Will you walk with me then?
Through the mountains, through the pines,
where clearings come suddenly
spilling with sun-pools and fern.
We will rest there, make love there,
sleep there, gaze up through the boughs
into the shoals of sky.

—*GEORGE MENDOZA*

Out of hope's eternal spring
Bubbled once my mountain stream
Moss and sundew, fern and fell,
Valley, summer, tree and sun
All rose up, and all are gone.

By the spring I saw my love
(All who have parted once must meet,
First we live, and last forget),
With the stars about his head
With the future in his heart
Lay the green earth at my feet.

Now by the spring I stand alone
Still are its singing waters flowing;
Oh never thought I here to greet
Shadowy death who comes this way
Where hope's waters rise and play!

—KATHLEEN RAINE
"The Spring"

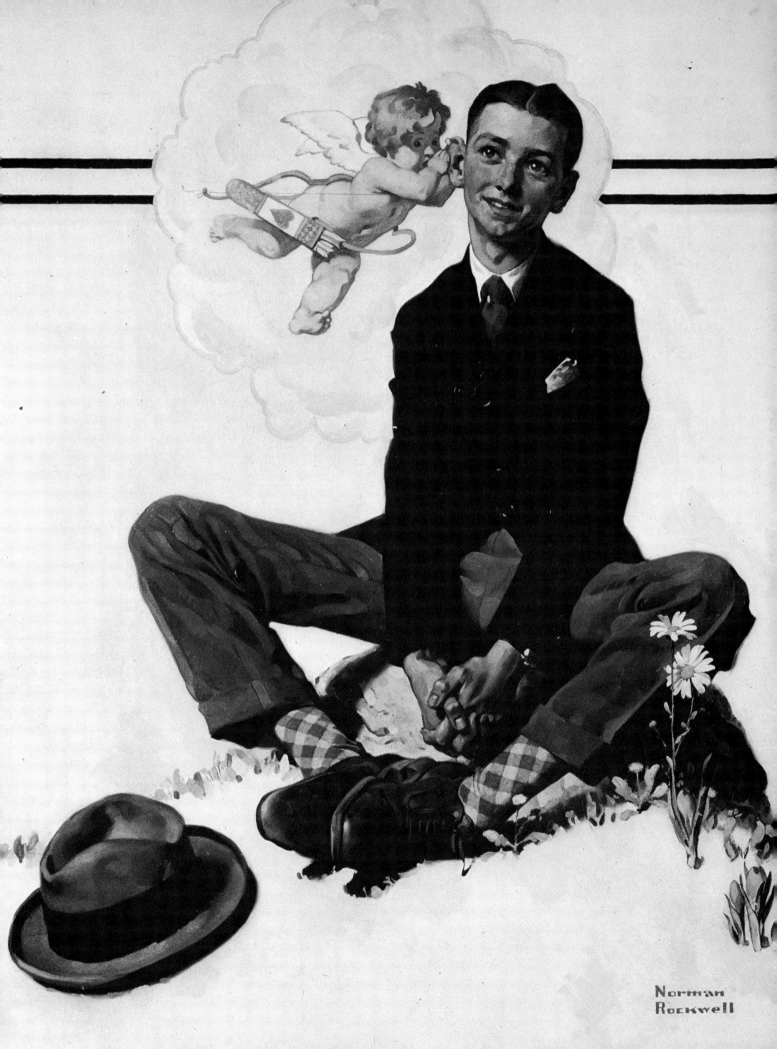

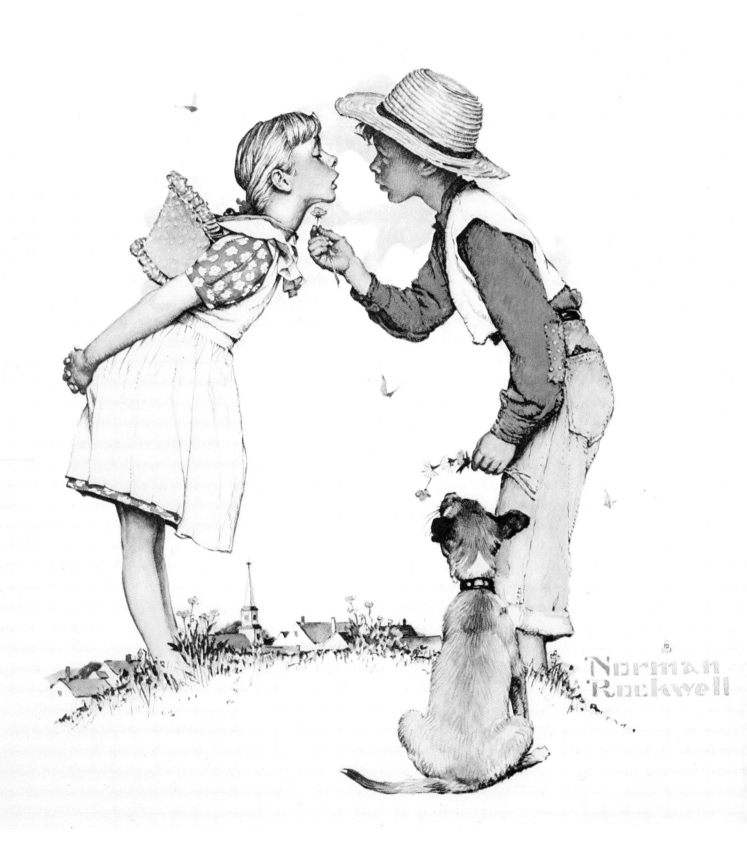

How fresh, O Lord, how sweet and clean
Are Thy returns! Even as the flowers in
 spring,
To which, besides their own demean,
The late-past frosts tributes of pleasure bring.
 Grief melts away
 Like snow in May,
As if there were no such cold thing.

—GEORGE HERBERT
from ''The Flower''

When daisies pied and violets blue
 And lady-smocks all silver-white
And cuckoo buds of yellow hue
 Do paint the meadows with delight,
The cuckoo then, on every tree,
Mocks married men; for thus sings he,
 Cuckoo;
Cuckoo, cuckoo: O word of fear,
Unpleasing to a married ear.

When shepherds pipe on oaten straws,
 And merry larks are ploughmen's clocks,
When turtles tread, and rooks, and daws,
 And maidens bleach their summer smocks,
The cuckoo then, on every tree,
Mocks married men; for thus sings he,
 Cuckoo;
Cuckoo, cuckoo; O word of fear,
Unpleasing to a married ear.

—WILLIAM SHAKESPEARE
"Spring"

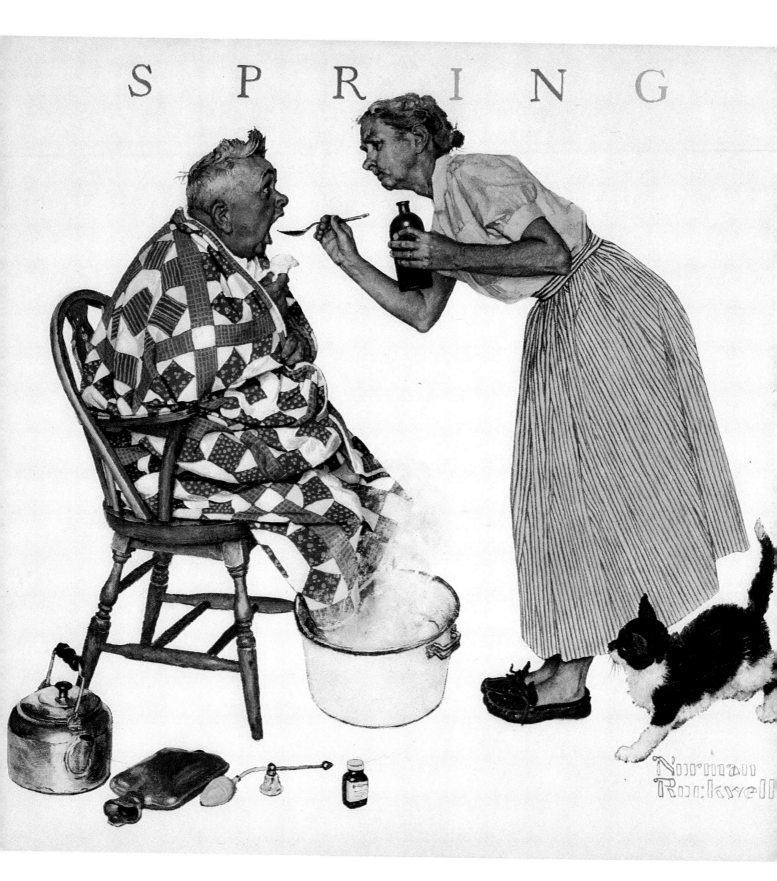

Covering the brook
a cocoon of mist.
Where is the sun
that will hatch it?

—GEORGE MENDOZA

To come upon a tree, such a tree,
braced and packed, cement in her
squirrel hollows,
trunk-scarred, blackened with paint.
Up high her leaves are wet,
her boughs old and stiff.
But round the tree in the young soft grass
as sweet as Spring
are pebbles, pebbles in the grass,
little white pebbles tooting at time like
 children
playing,
while old roots gnarl the wind.

—GEORGE MENDOZA

Loveliest of trees, the cherry now
Is hung with bloom along the bough,
And stands about the woodland ride
Wearing white for Eastertide.

Now, of my threescore years and ten,
Twenty will not come again,
And take from seventy springs a score,
It only leaves me fifty more.

And since to look at things in bloom
Fifty springs are little room,
About the woodlands I will go
To see the cherry hung with snow.

—A. E. HOUSMAN
"Loveliest of Trees"

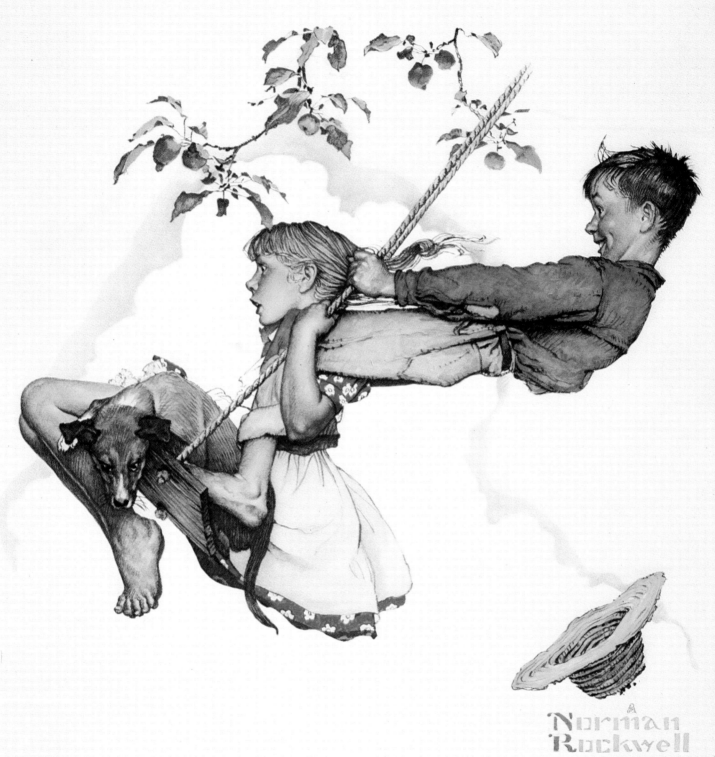

SPRING

Norman Rockwell

Sound the flute!
Now it's mute.
Birds delight
Day and Night;
Nightingale,
In the dale,
Lark in the Sky,
Merrily,
Merrily, merrily, to welcome in the Year.

Little Boy,
Full of joy:
Little Girl,
Sweet and small;
Cock does crow,
So do you;
Merry voice,
Infant noise,
Merrily, merrily, to welcome in the Year.

Little Lamb
Here I am;
Come and lick
My white neck;
Let me pull
Your soft Wool;
Let me kiss
Your soft face;
Merrily, merrily, we welcome in the Year.

—WILLIAM BLAKE
"Spring"

It was a lover and his lass,
 With a hey, and a ho, and a hey nonino,
That o'er the green corn-field did pass,
 In the spring time, the only pretty ring
 time,
When birds do sing, hey ding a ding, ding;
Sweet lovers love the spring.

Between the acres of the rye,
 With a hey, and a ho, and a hey nonino,
These pretty country folks would lie,
 In the spring time, the only pretty ring
 time,
When birds do sing, hey ding a ding, ding;
Sweet lovers love the spring.

This carol they began that hour,
 With a hey, and a ho, and a hey nonino,
How that life was but a flower
 In the spring time, the only pretty ring
 time,
When birds do sing, hey ding a ding, ding;
Sweet lovers love the spring.

And, therefore, take the present time
 With a hey, and a ho, and a hey nonino,
For love is crownèd with the prime
 In the spring time, the only pretty ring
 time,
When birds do sing, hey ding a ding, ding;
Sweet lovers love the spring.

—WILLIAM SHAKESPEARE
"It was a Lover and his Lass"

Spring is like a perhaps hand
(which comes carefully
out of Nowhere) arranging
a window, into which people look (while
people stare
arranging and changing placing
carefully there a strange
thing and a known thing here) and

changing everything carefully

spring is like a perhaps
Hand in a window
(carefully to
and fro moving New and
Old things,while
people stare carefully
moving a perhaps
fraction of flower here placing
an inch of air there) and

without breaking anything.

—e. e. cummings
"Spring is like a perhaps hand"

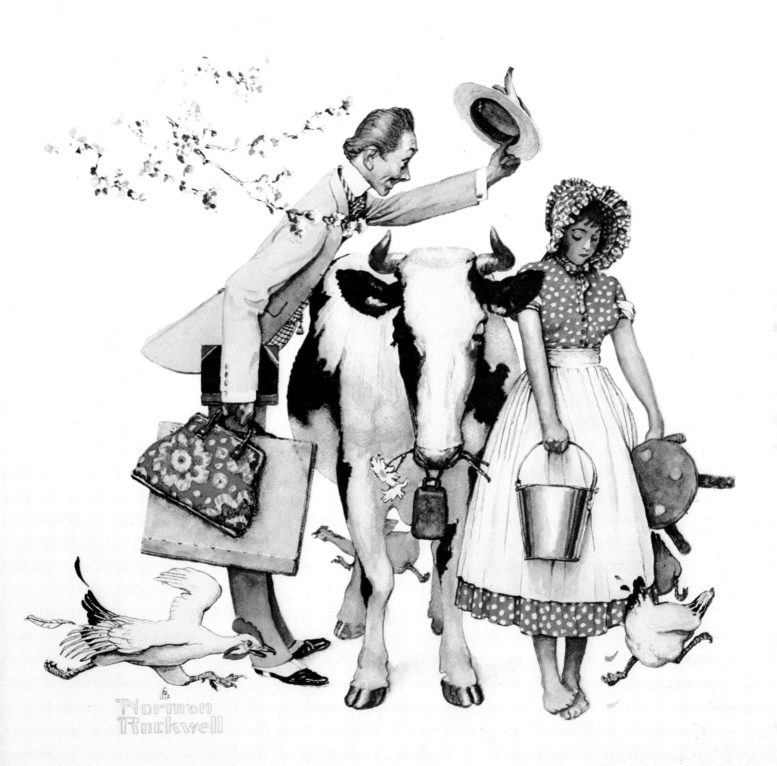

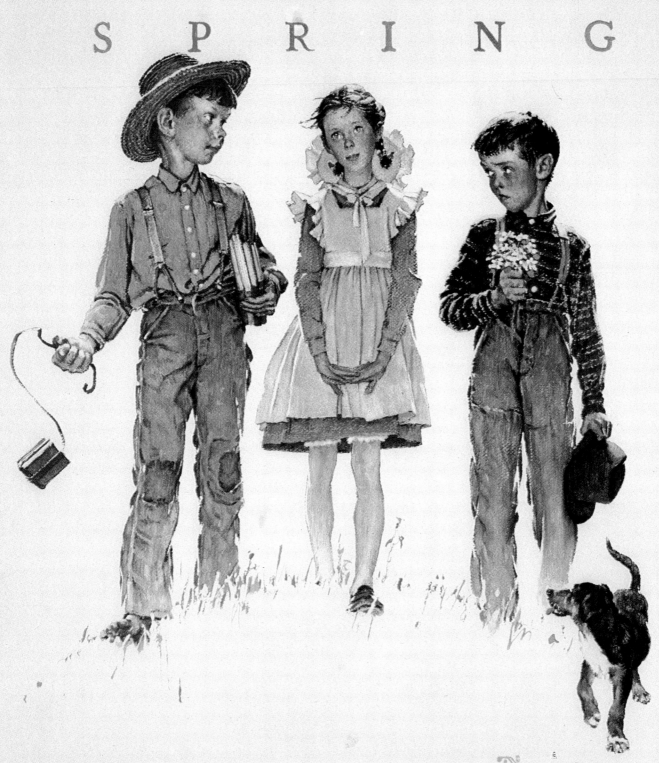

Fair daffodils, we weep to see
 You haste away so soon;
As yet the early-rising sun
 Has not attain'd his noon.
 Stay, stay
 Until the hasting day
 Has run
 But to the evensong;
And, having pray'd together, we
 Will go with you along.

We have short time to stay, as you,
 We have as short a spring;
As quick a growth to meet decay,
 As you, or anything.
 We die
 As your hours do, and dry
 Away
 Like to the summer's rain;
Or as the pearls of morning's dew,
 Ne'er to be found again.

—ROBERT HERRICK
"To Daffodils"

I wander'd lonely as a cloud
 That floats on high o'er vales and hills,
When all at once I saw a crowd,
 A host, of golden daffodils;
Beside the lake, beneath the trees,
Fluttering and dancing in the breeze.

Continuous as the stars that shine
 And twinkle on the Milky Way,
They stretch'd in never-ending line
 Along the margin of a bay:
Ten thousand saw I at a glance,
Tossing their heads in sprightly dance.

The waves beside them danced, but they
 Out-did the sparkling waves in glee:
A poet could not but be gay,
 In such a jocund company:
I gazed—and gazed—but little thought
What wealth the show to me had brought:

For oft, when on my couch I lie
 In vacant or in pensive mood,
They flash upon that inward eye
 Which is the bliss of solitude;
And then my heart with pleasure fills,
And dances with the daffodils.

 —WILLIAM WORDSWORTH
 "Daffodils"

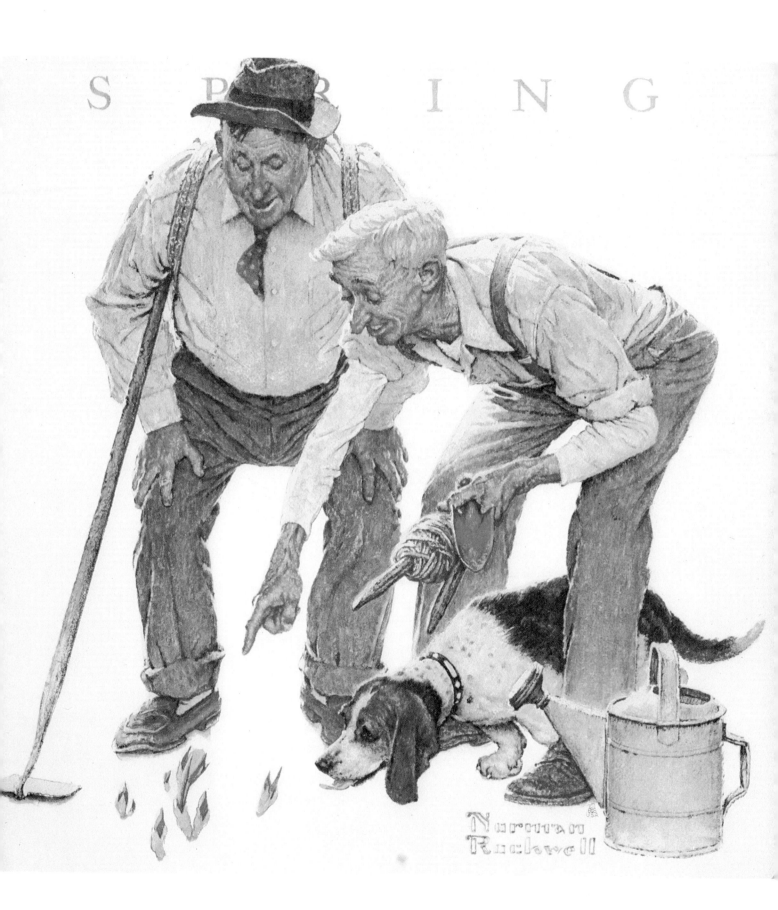

For my Spring Child
your first doll.
I remember her in the window.
Soft peach face in a Paris store
with red lips and curls
and a blue and yellow print dress.
She was all flowers in her straw hat.
"I'll be Ashley's forever," I heard her smile.
Oh, moment of enchantment!
Not so far away.

—GEORGE MENDOZA
"Ashley's Doll"

Oh, give us pleasure in the flowers to-day;
And give us not to think so far away
As the uncertain harvest; keep us here
All simply in the springing of the year.

Oh, give us pleasure in the orchard white,
Like nothing else by day, like ghosts by night;
And make us happy in the happy bees,
The swarm dilating round the perfect trees.

And make us happy in the darting bird
That suddenly above the bees is heard,
The meteor that thrusts in with needle bill,
And off a blossom in mid air stands still.

For this is love and nothing else is love,
The which it is reserved for God above
To sanctify to what far ends He will,
But which it only needs that we fulfil.

—ROBERT FROST
"A Prayer in Spring"

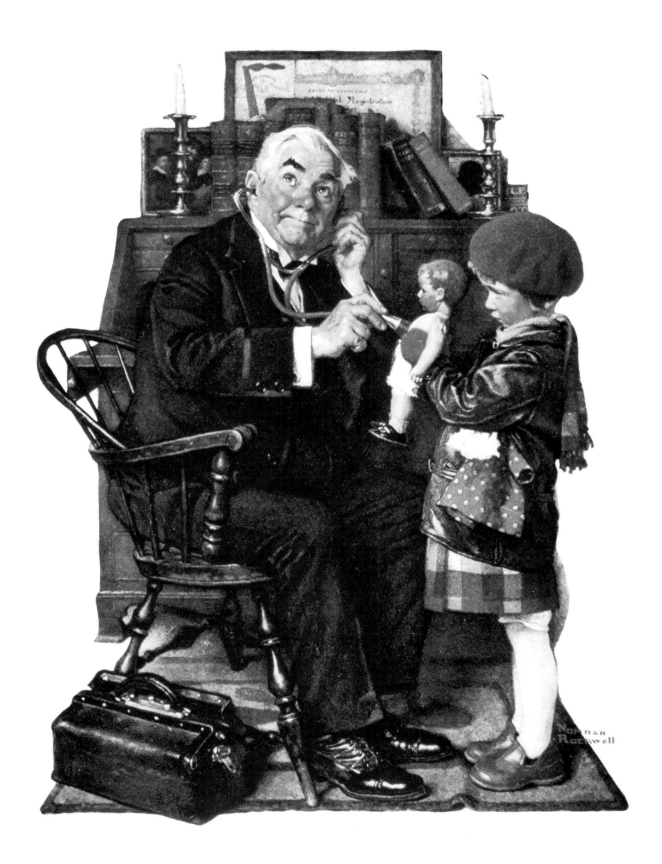

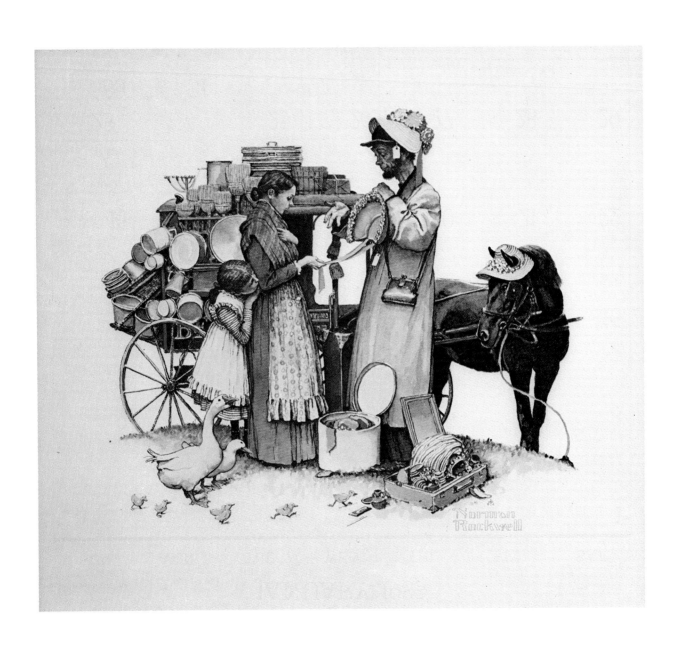

Spring, the sweet Spring, is the year's
 pleasant king;
Then blooms each thing, then maids dance in
 a ring,
Cold doth not sting, the pretty birds do
 sing—
 Cuckoo, jug-jug, pu-we, to-witta-woo!

The palm and may make country houses gay,
Lambs frisk and play, the shepherds pipe all
 day,
And we hear aye birds tune this merry lay—
 Cuckoo, jug-jug, pu-we, to-witta-woo!

The fields breathe sweet, the daisies kiss our
 feet,
Young lovers meet, old wives a-sunning sit,
In every street these tunes our ears do greet—
 Cuckoo, jug-jug, pu-we, to-witta-woo!
 Spring, the sweet Spring!

—THOMAS NASHE
"Spring"

I dream'd that, as I wander'd by the way,
 Bare Winter suddenly was changed to
 Spring;
And gentle odours led my steps astray,
 Mix'd with a sound of waters murmuring
Along a shelving bank of turf, which lay
 Under a copse, and hardly dared to fling
Its green arms round the bosom of the
 stream,
But kiss'd it and fled, as thou mightest in
 dream.

—PERCY BYSSHE SHELLEY
from "The Question"

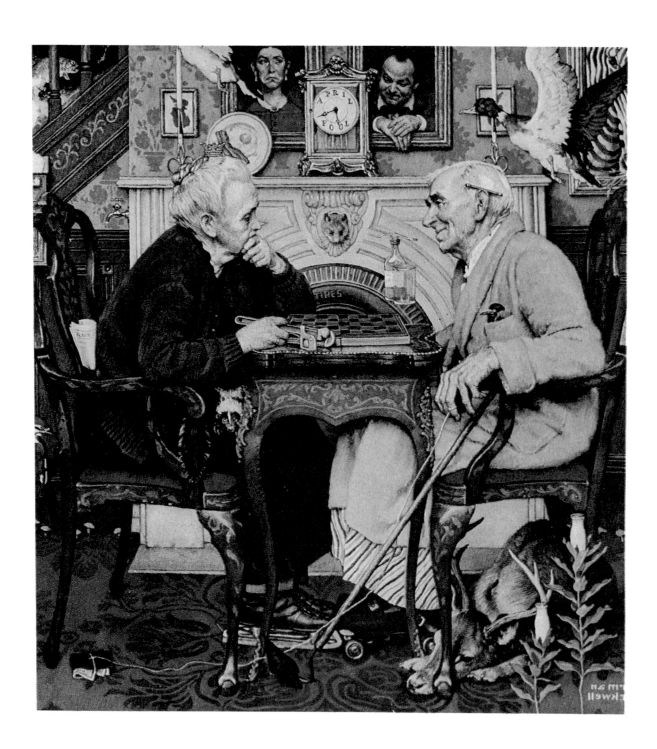

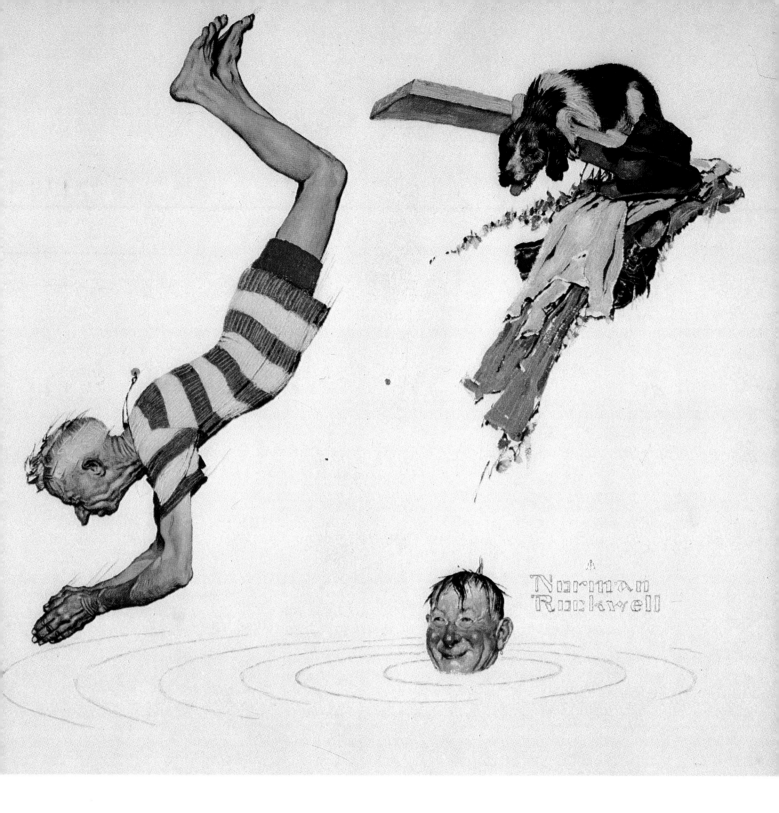

In all this cool
 is the moon also sleeping?
 There, in the pool?

—*RYUSUI*
"Coolness in Summer"

Shall I compare thee to a summer's day?
Thou art more lovely and more temperate:
Rough winds do shake the darling buds of
 May,
And summer's lease hath all too short a date.
Sometimes too hot the eye of heaven shines,
And often is his gold complexion dimm'd;
And every fair from fair sometimes declines,
By chance, or nature's changing course
 untrimm'd;
But thy eternal summer shall not fade,
Nor lose possession of that fair thou owest;
Nor shall Death brag thou wander'st in his
 shade,
When in eternal lines to time thou growest:
 So long as men can breathe, or eyes can
 see,
 So long lives this, and this gives life to thee.

 —WILLIAM SHAKESPEARE
 Sonnet 18

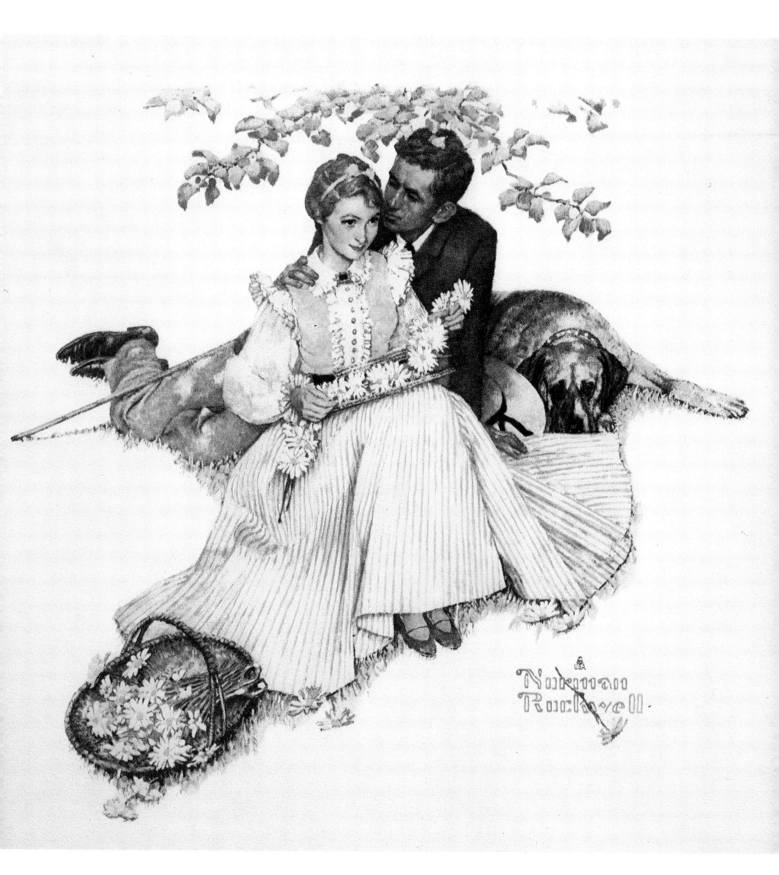

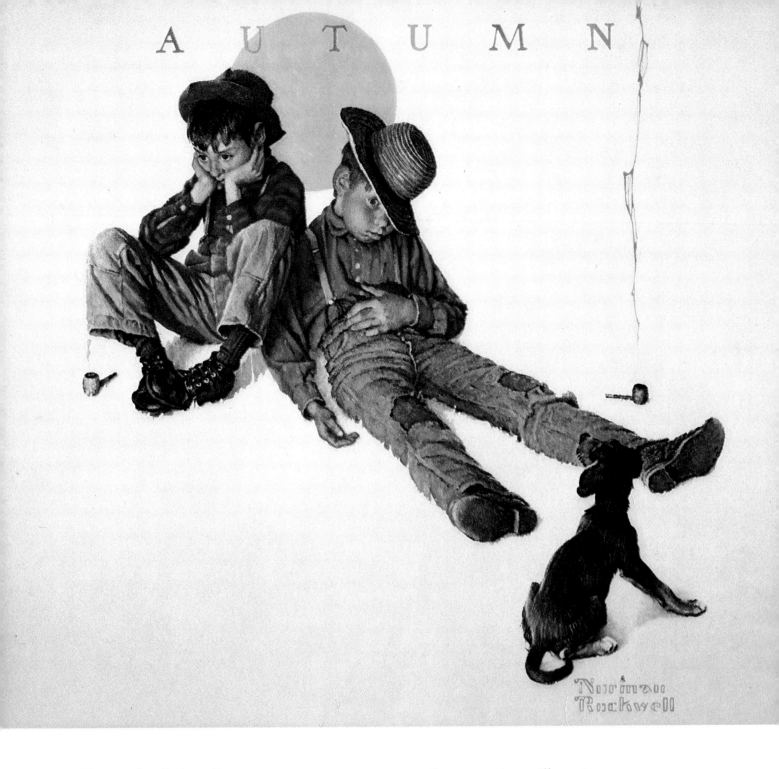

AUTUMN

The road splitting dirt
between two fields
high, once high,
moon in the wheat.
Below the iron bridge
we go:
two boys lost,
looking for downstream dreams.

—*GEORGE MENDOZA*

I am a water-mill poet . . .
can you hear the wheel scooping?
I am a willow-tree poet . . .
can you see the tree differently?

—*GEORGE MENDOZA*

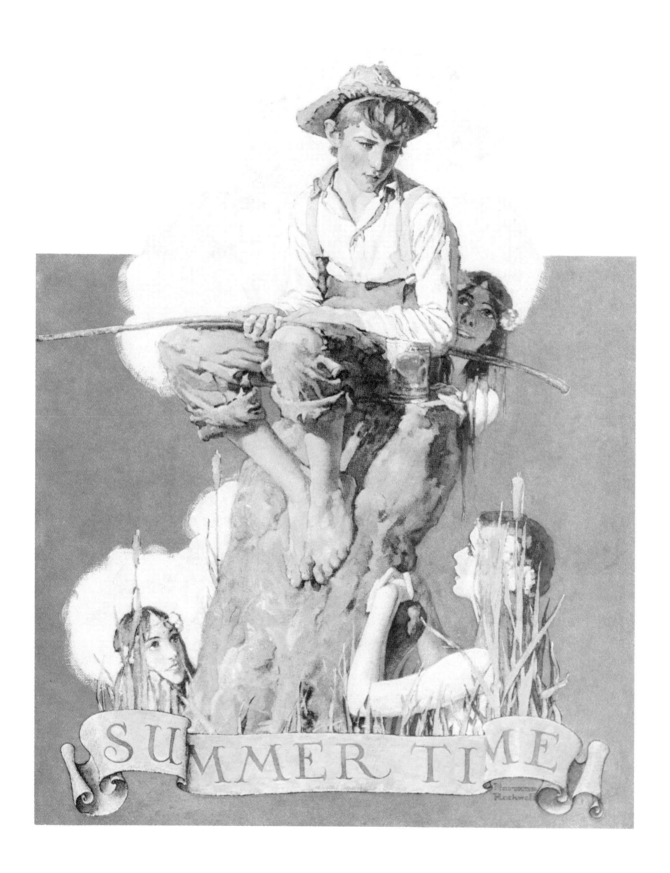

The trap I set
 is not a death-clap
 of chain and steel and spring
to crunch a hare's bone,
but the sky's open net
of stars like spoon-dust
gathered on a blinding brook.
O I've sent the sun spinning O
like a marble shot to the pot,
the moon I've scooped up
in my scooper
like a squid in the sea
to light the tails of fireflies,
for the forest takes me deep
where pine and birch and fern
are giant seaweed swaying under,
and the fox, and owl, and hawk and snake
are as fish in a sea of fog.

—GEORGE MENDOZA

I'm a dream time man
when the mayfly flies,
caught in a crooked dance
between fish and bird,
beating with the brook my day-night song
till the sky can't hold me
and I'm a swallowed up, juicy bug.

—GEORGE MENDOZA

Summer's coming,
the sky sows it:
the nest is empty.
Only horse hair and cow hair
pecked from rutted fields remain
where the first feathers
had felt the wind
and little hot bellies pressed close,
like three children lost in snow,
and black eyes went blinking and
beaks opened for peeping.
Now the egg-like crater
cradles summer in the nest
and around it twigs
carved from air.

—GEORGE MENDOZA

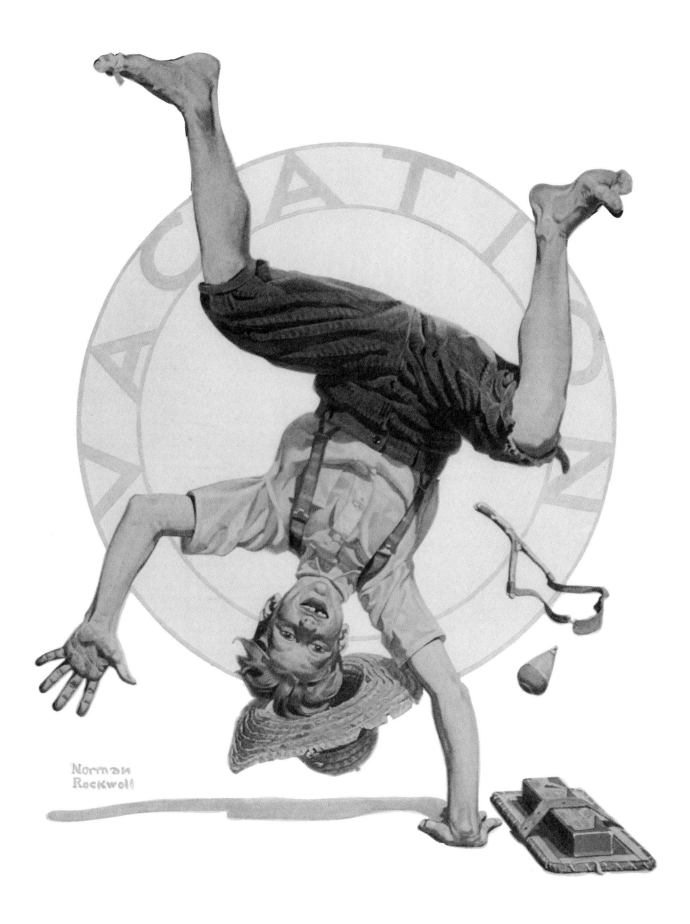

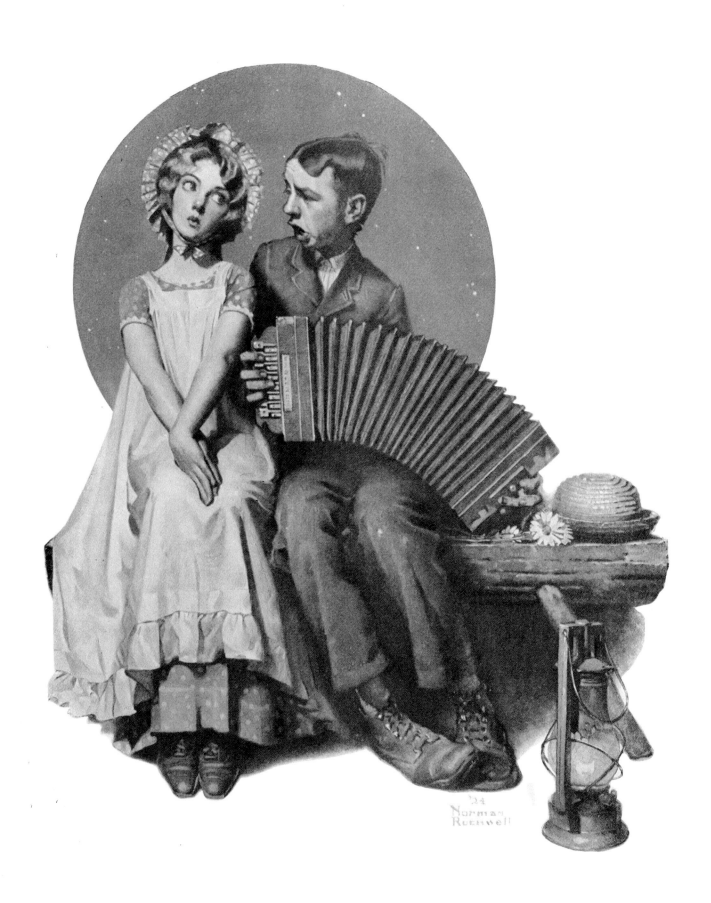

A trout is a tune
and the river
a flute . . .
when the woods
are bent
and arranged by God.

—GEORGE MENDOZA

Summer has two beginnings,
Beginning once in June,
Beginning in October
Affectingly again,

Without perhaps the riot,
But graphicker for grace—
As finer is a going
Than a remaining face—

Departing then forever,
Forever until May.
Forever is deciduous
Except to those who die.

—ALGERNON CHARLES SWINBURNE
"Summer Has Two Beginnings"

The sky, the woods, the stars
are boulders,
but pebbles, pebbles seem older.

—GEORGE MENDOZA

When time was a boy
I brought the summer earth humming
to my head
and looked at a mountain
through a blade of grass.
The blade of grass, I saw, was taller than the
mountain.
The blade of grass, I dreamed, was taller than
the world.
So I picked it and stuffed it in my pocket,
a mountain and a world.

—GEORGE MENDOZA

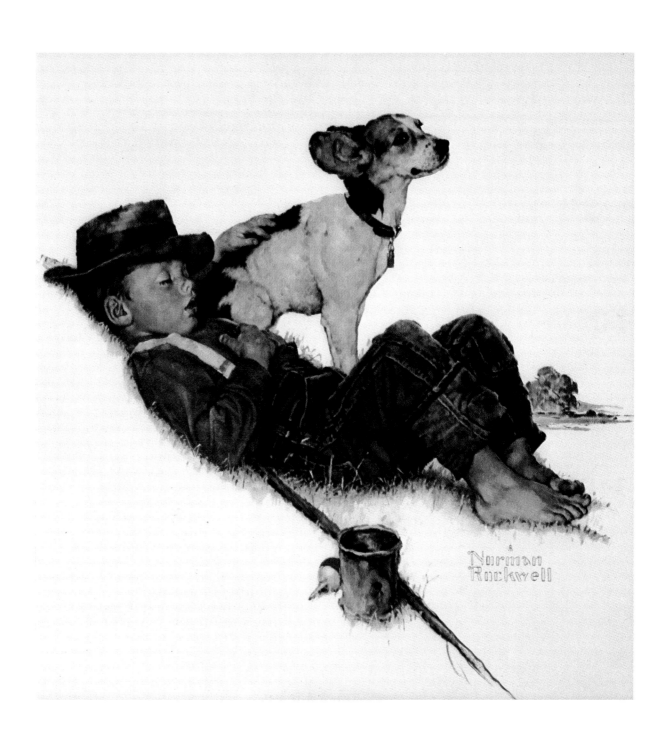

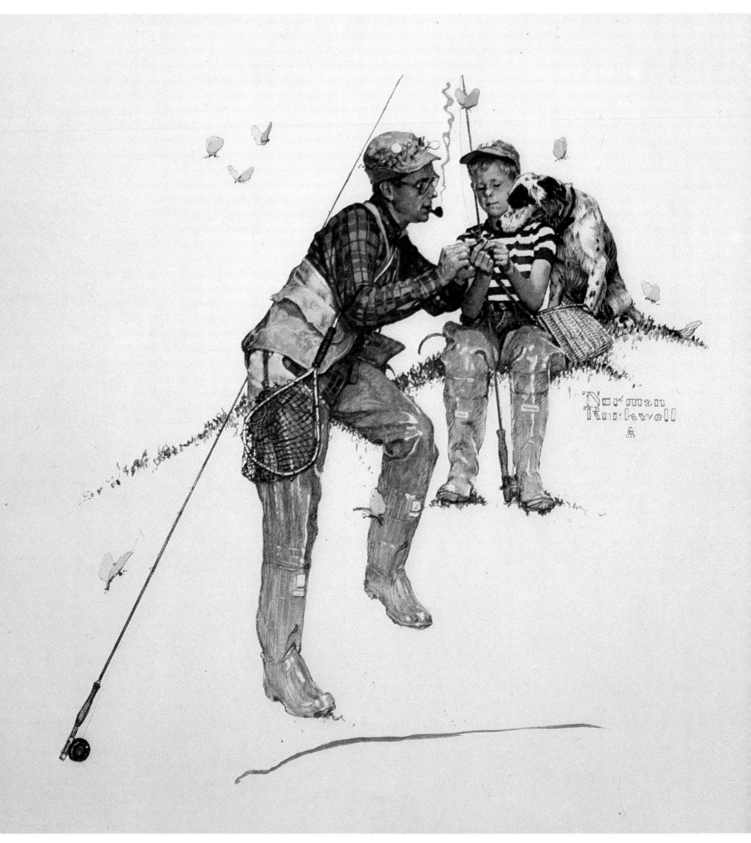

Across the meadow-wide
pressing leaves
down to the turtle stones,
fisherman's boots,
waking the morning, turning the world,
tuning the grass.

—GEORGE MENDOZA

All night
with his cane and his leg stiff
he fished the deeps and shallows of the river.
Like a bat he stalked the bold browns
that foraged for frogs and mice along the banks.

All night
he lived to feel the pluck of his honey-spider fly.
Floating it out in the dark he felt it drift down
in moonless currents as though it were his
 own heart
and with his fingers feeling the pulse of the line
he spoke to the little stars,
spoke to them all night
till they went out.

—GEORGE MENDOZA

Have you got a Brook in your little heart,
Where bashful flowers blow,
And blushing birds go down to drink,
And shadows tremble so—

And nobody knows, so still it flows,
That any brook is there,
And yet your little draught of life
Is daily drunken there—

Why, look out for the little brook in March,
When the rivers overflow,
And the snows come hurrying from the hills,
And the bridges often go—

And *later,* in *August* it may be—
When the meadows parching lie,
Beware, lest this little brook of life,
Some burning noon go dry!

—EMILY DICKINSON

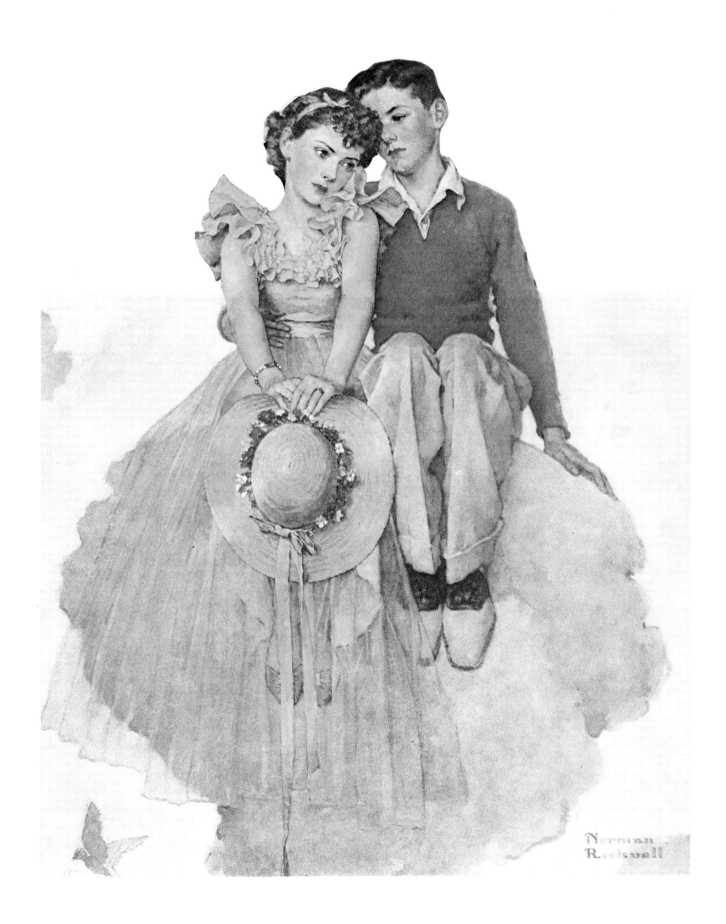

fishing the morning lonely
I'm looking up at the sky
telling myself
why I'm who
and how do you do
black and yellow waxwing
why can't I fly like you?
My head is a box
of beautiful gears
I know more than I know
and I know less than—
Henry David Thoreau.

fishing the morning lonely
is a song I'm thinking out
when I think I've got it
I'll let you know
but I won't use the telephone
and don't go expecting
a letter
because I don't have a
stamp to my
noname.

—*GEORGE MENDOZA*
"fishing the morning lonely"

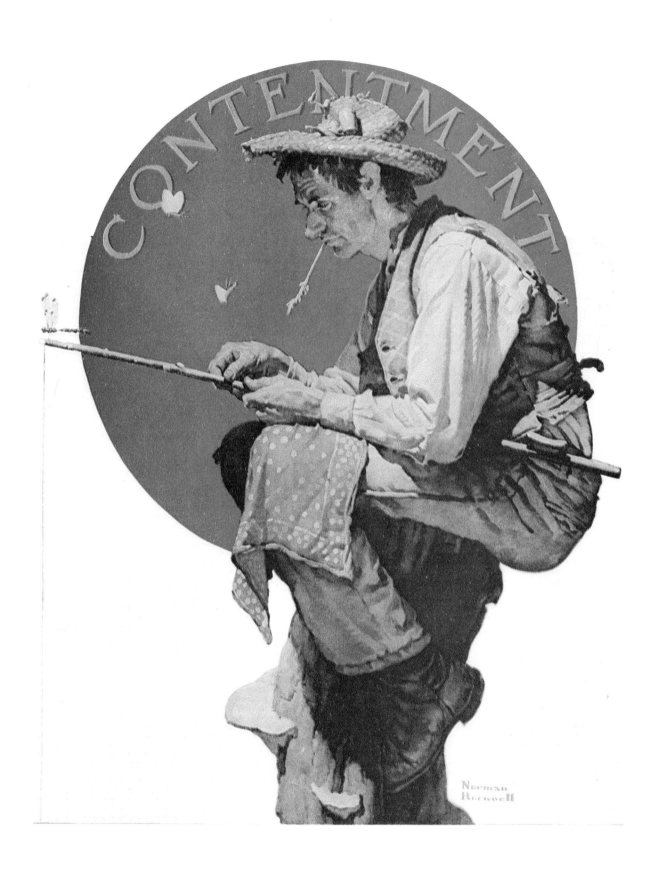

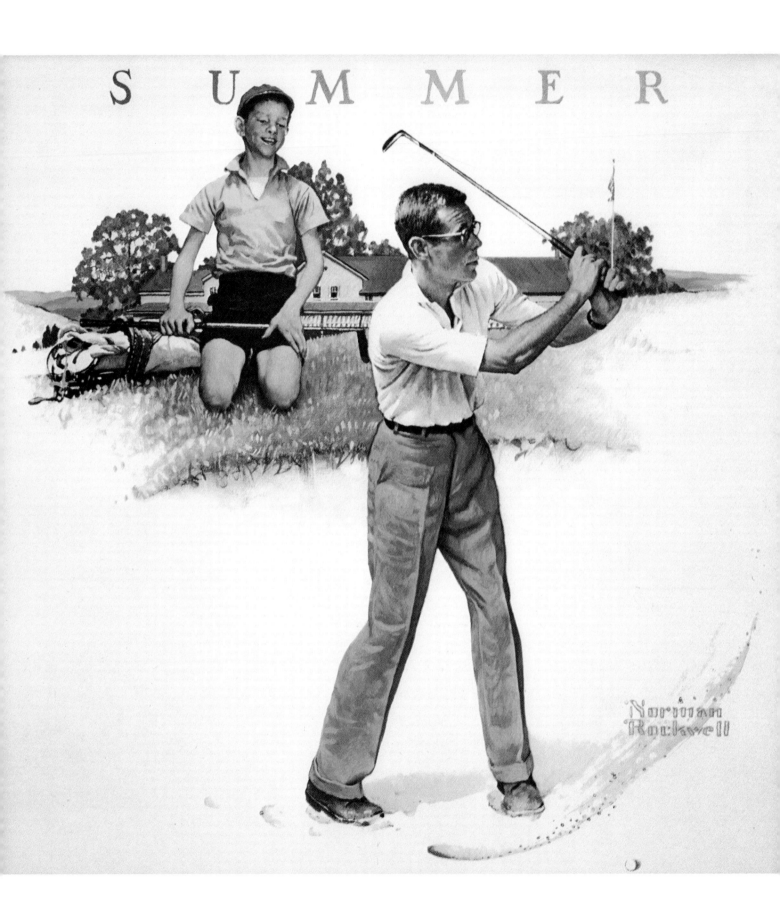

Who cannot remember his father?
Are you not the son?
All his son?
Is he not the father of your tidal desires?
Are you not the son of his dark spun songs?
O speak the son, where is the son,
who would crush a feather of his father's
soarings?

—GEORGE MENDOZA

O my Luve's like a red, red rose
 That's newly sprung in June:
O my Luve's like the melodie
 That's sweetly play'd in tune!

As fair art thou, my bonnie lass,
 So deep in luve am I:
And I will luve thee still, my dear,
 Till a' the seas gang dry:

Till a' the seas gang dry, my dear,
 And the rocks melt wi' the sun;
I will luve thee still, my dear,
 While the sands o' life shall run.

And fare thee weel, my only Luve,
 And fare thee weel a while!
And I will come again, my Luve,
 Tho' it were ten thousand mile.

—ROBERT BURNS
"A Red, Red Rose"

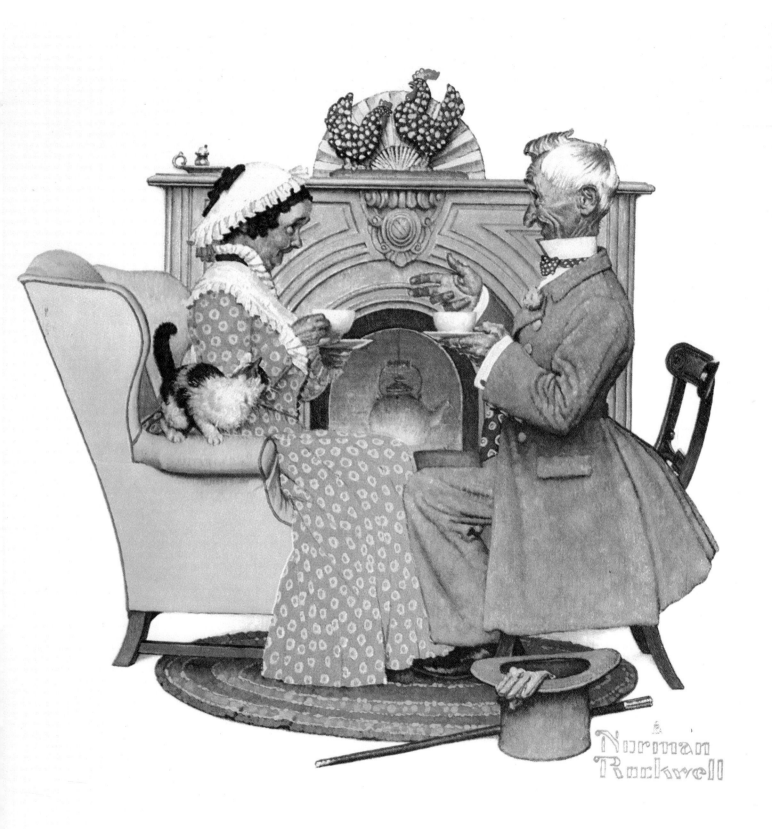

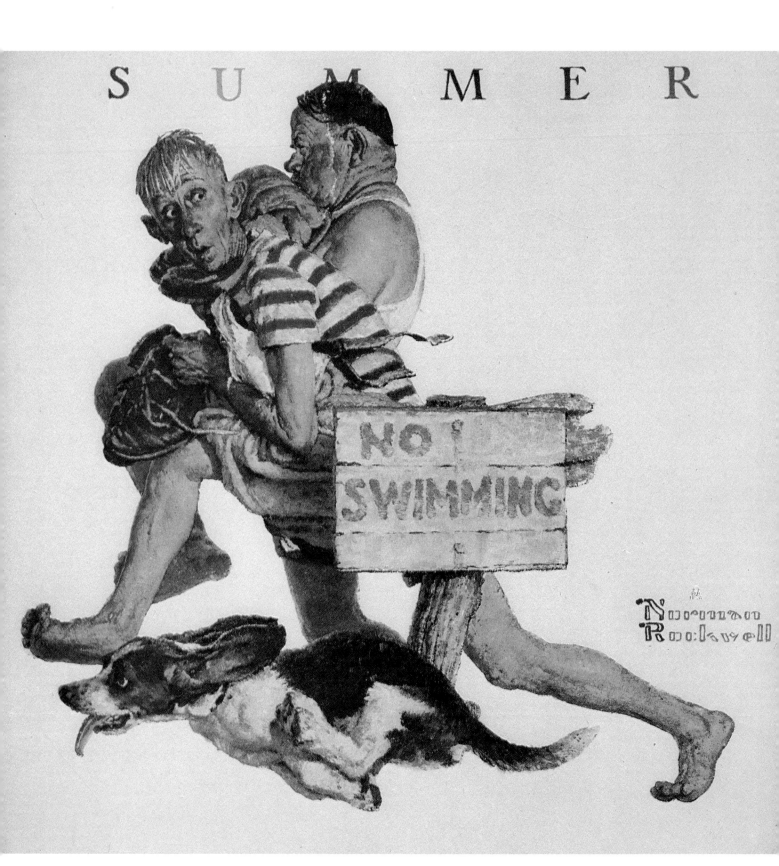

Where the pools are bright and deep,
Where the grey trout lies asleep,
Up the river and over the lea,
That's the way for Billy and me.

Where the blackbird sings the latest,
Where the hawthorn blooms the sweetest,
Where the nestlings chirp and flee,
That's the way for Billy and me.

Where the mowers mow the cleanest,
Where the hay lies thick and greenest,
There to track the homeward bee,
That's the way for Billy and me.

Where the hazel bank is steepest,
Where the shadow falls the deepest,
Where the clustering nuts fall free,
That's the way for Billy and me.

Why the boys should drive away
Little sweet maidens from the play,
Or love to banter and fight so well,
That's the thing I never could tell.

But this I know, I love to play
Through the meadow, among the hay;
Up the water and over the lea,
That's the way for Billy and me.

—JAMES HOGG
"A Boy's Song"

fog sifts down the mountain
a bird flashes out of the brush
and disappears into the low sky:
it seems as though the world
wants us to listen to it:
beyond the silence
is there something
you hear?

—GEORGE MENDOZA

I saw three birds
taking a bath
in the park.
One robin,
two common.
The robin flew off,
he was first;
three commoners stayed
a little longer to bathe.

—GEORGE MENDOZA
*"On a misty Sunday morning
after a rainy-O-Saturday night"*

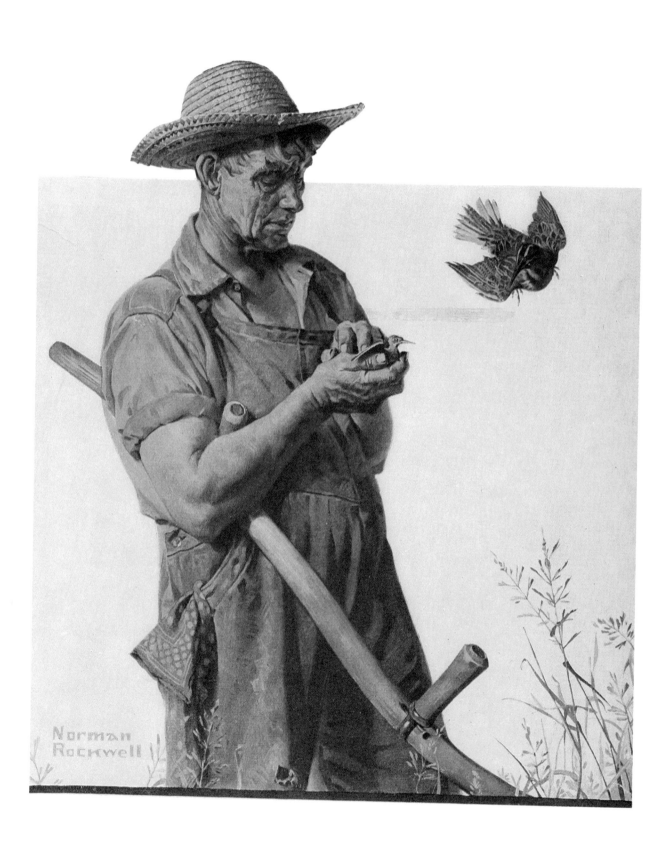

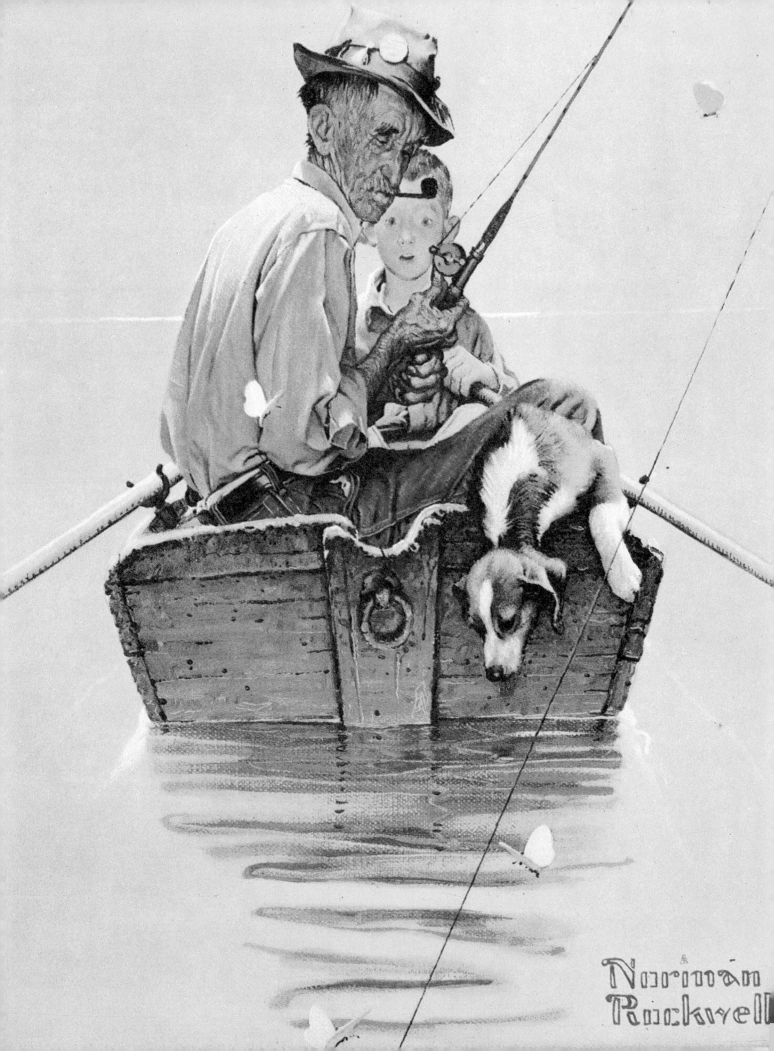

We were two little people
drifting in our boat
across the pond
casting three flies a-time for rainbows,
when the thunder rolled, rumbling over the
mountain.
"Can you hear the rain?" I said to my wife
as she looked up to the mountain.
"Listen . . ." she said
and the birches turned their leaves silvery in
 the dark.
"It's coming . . ."
"We'd better go back," I said, feeling the first
drops of rain reach us.
"Let it!" She laughed
and we drifted under the angry clouds
licking rain like sweet sap from the bark
of our faces.

 —GEORGE MENDOZA
 "We Were Two Little People"

I'd like to say
c'mon let's go,
let's hit the road
we'll take our chances,
you got some left?
We'll live like sparrows
for a little less fat!

 —GEORGE MENDOZA

To drink the dark
you do it now.
Are you tree
or stone?
Fish or winged flash?
You've come alone
the moon sets your pipe
aglow.
You flame the fishes eye
while stars scatter through your net.

 —GEORGE MENDOZA

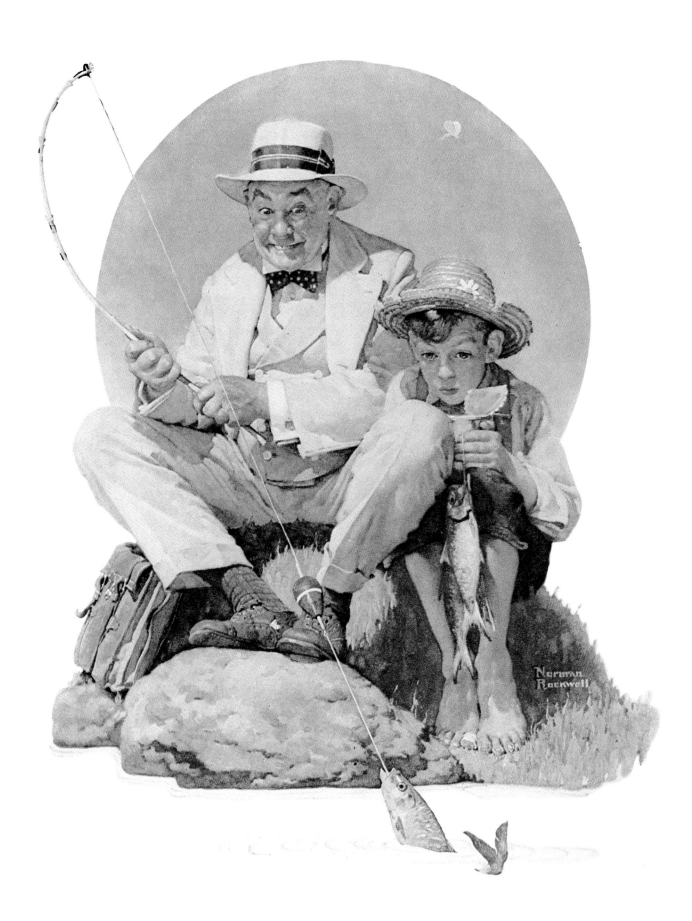

Men I have known
search out the little streams
green-washed, pebbly gray
that run like long forest veins
down to the wider suddenly darker place
called river—
for the fishes anchor there
in fleets like bobbing boats
finning time under the whistling pickerel beds
till they leave the moon's eye
wedged in the night
between the gravely stones . . .
have you seen the place
across the river
where the little stream
runs like the silver fur of a flashing fox?
It's gone now.

—GEORGE MENDOZA

fish gold, fish red
little fish,
brook fish born native,
like a flashing flower
wild as seed—
do not be taken!
go down, go deep,
into the invisible deep
till the moon-leaves
net the mountain night
and the forest has lost
its trail.

—GEORGE MENDOZA

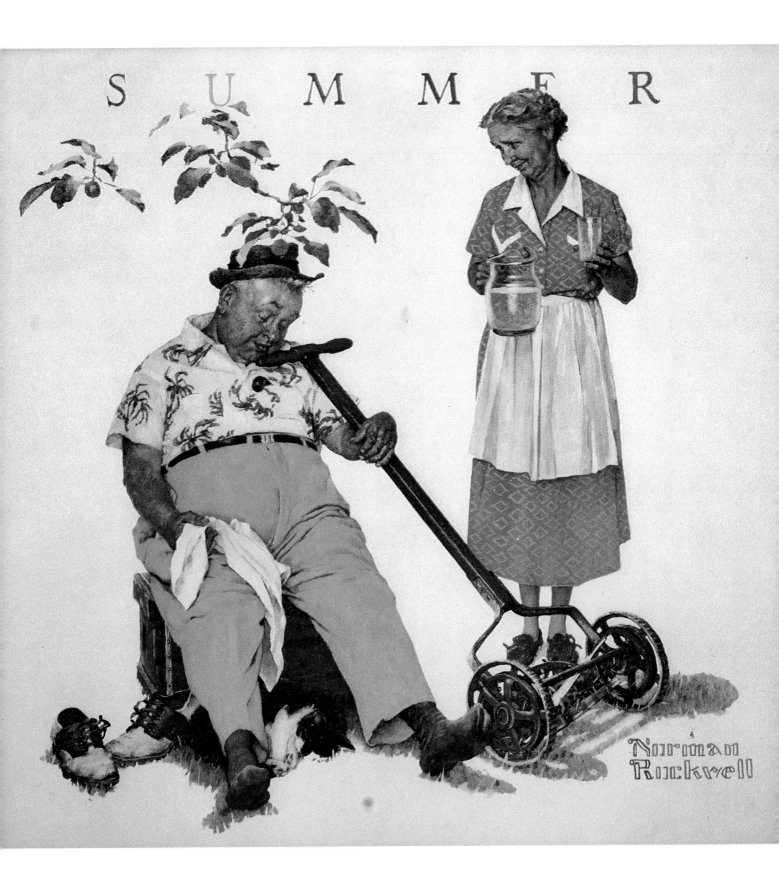

In winter I get up at night
And dress by yellow candle-light.
In summer, quite the other way,
I have to go to bed by day.

I have to go to bed and see
The birds still hopping on the tree.
Or hear the grown-up people's feet
Still going past me in the street.

And does it not seem hard to you,
When all the sky is clear and blue,
And I should like so much to play,
To have to go to bed by day?

—*ROBERT LOUIS STEVENSON*
"Bed in Summer"

I had a calling
to wander like a drifter man
from town to town . . .
to look into dusty windows
that never looked back at me . . .
I've sailed across many roads
hitched-up to things behind
I didn't understand.

I've slept in the orchards of a flower
along the lonely tracks
of beggar trains
that clinked upon the rails of mournful
 dreams.

I've walked the shores of sea
when the seasons were tunes of solitude . . .
I've larked in the nests of sun-falls
pooled in clearings carved from wood . . .
I'll say on a penny's toss,
I've gone ahead of you, Sir . . .

I've floated in the knots of moon-drifts
when the hills were waves of golden
 flows . . .
I've let the stars fall upon me
until I could taste the light-year wine . . .
my soul,
I've given to the silken rain . . .
I've followed the river of meadow days
when the little plum fish
were waxing their pebbly beds . . .
I've made love in Heaven
to a creature of rare petal dust . . .
I've gone ahead of you, Sir . . .
and beyond myself—
because I was hitched-up
to things behind
I didn't understand.

—GEORGE MENDOZA
"I've gone ahead of you, Sir"

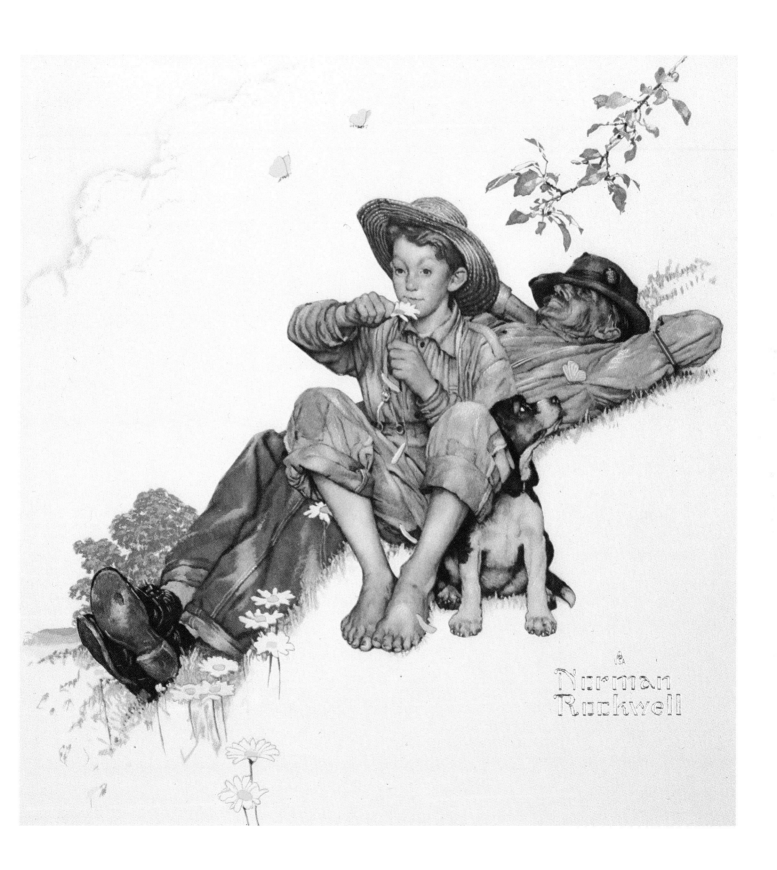

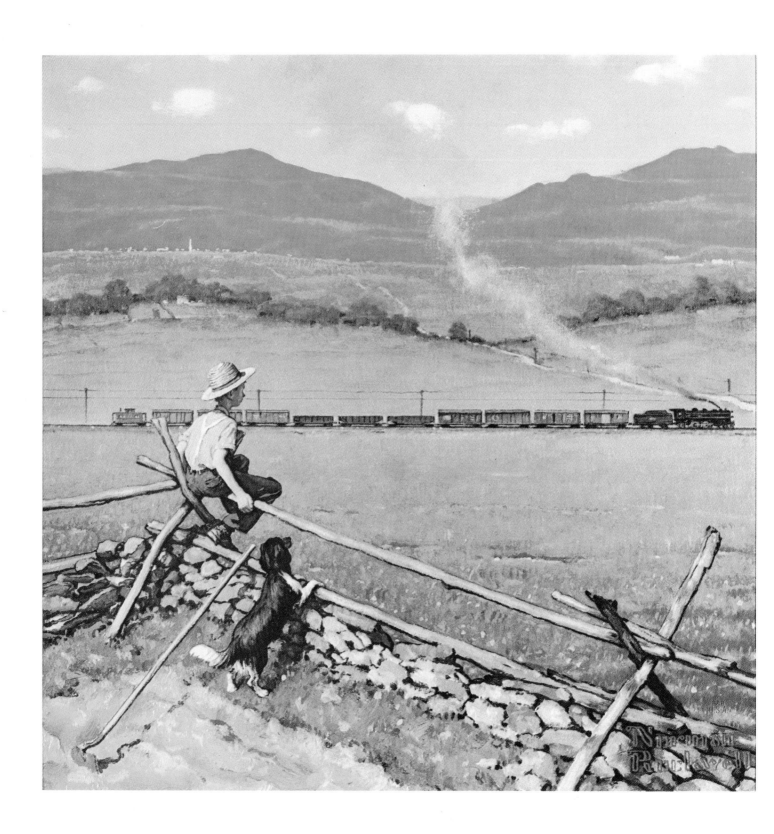

I like to see it lap the miles,
And lick the valleys up,
And stop to feed itself at tanks;
And then, prodigious, step

Around a pile of mountains,
And, supercilious, peer
In shanties by the sides of roads;
And then a quarry pare

To fit its sides, and crawl between,
Complaining all the while
In horrid, hooting stanza;
Then chase itself down hill

And neigh like Boanerges;
Then, punctual as a star,
Stop—docile and omnipotent—
At its own stable door.

—EMILY DICKINSON
"The Train"

I was born on a train
crossing a bridge.
The tracks were my home
swung high, swung high
over a river deep,
wedged blue between two mountains.
You know where you're going?
My mind has no map.
I'm rounding a bend
called gliding weed . . .
I'm rounding a bend
called plucking time . . .
I'm rounding a bend
called dreaming fields . . .
and my windows keep changing . . .
and my windows keep changing . . .

—GEORGE MENDOZA

My heart leaps up when I behold
 A rainbow in the sky:
So was it when my life began,
So is it now I am a man,
So be it when I shall grow old
 Or let me die!
The Child is father of the Man:
And I could wish my days to be
Bound each to each by natural piety.

—WILLIAM WORDSWORTH
"My Heart Leaps Up"

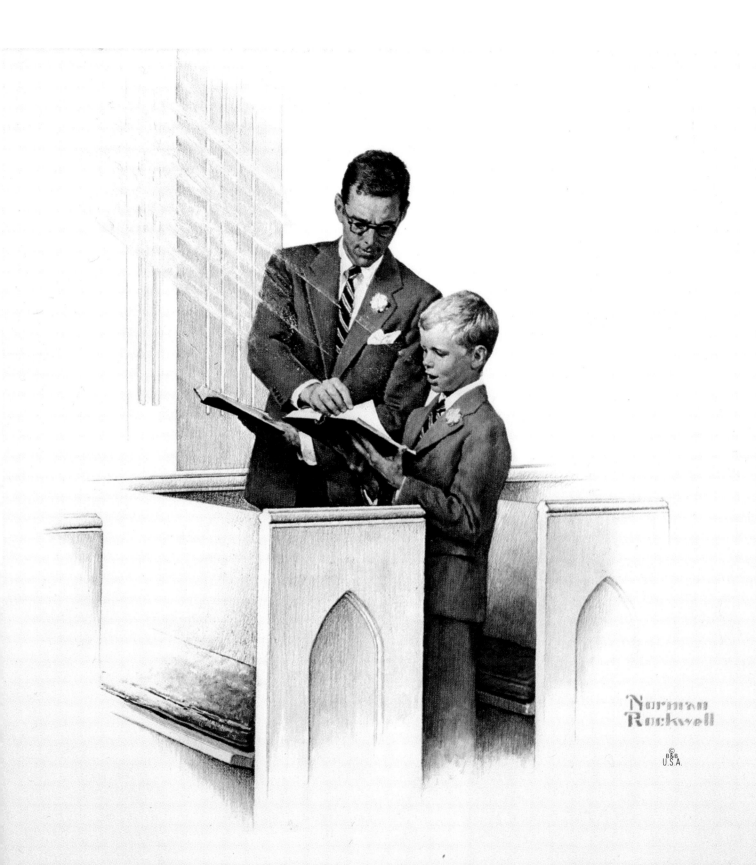

Norman
Rockwell

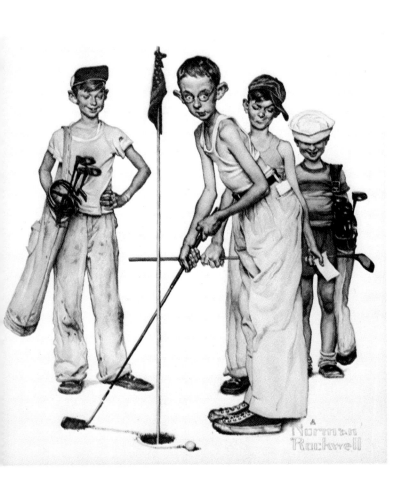

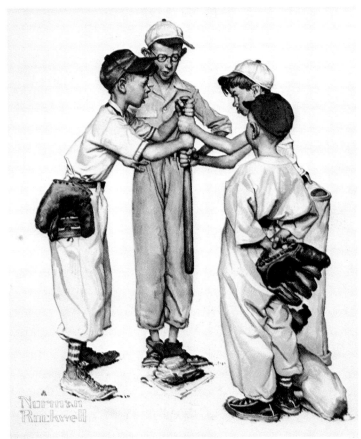

What is this life if, full of care,
　　We have no time to stand and stare?—
　　No time to stand beneath the boughs
And stare as long as sheep or cows:
No time to see, when woods we pass,
Where squirrels hide their nuts in grass:
No time to see, in broad daylight,
Streams full of stars, like skies at night:
No time to turn at Beauty's glance,
And watch her feet, how they can dance:
No time to wait till her mouth can
Enrich that smile her eyes began?
A poor life this if, full of care,
We have no time to stand and stare.

—*WILLIAM HENRY DAVIES*
"Leisure"

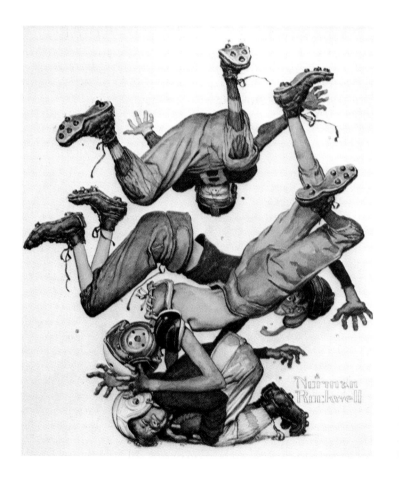

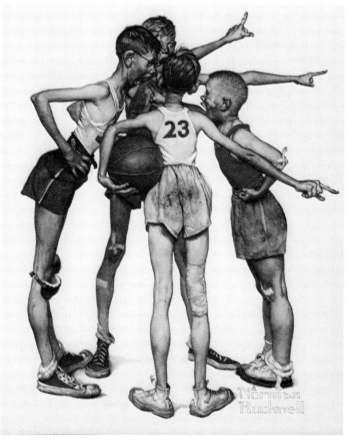

Things come inside a man
understand . . .
to be on a road, any road.
A road between fields,
a road between hills,
a road between clouds,
a road between roads,
sometimes I feel it come
inside me, strong
like the weight of all my days
behind me . . .
a voice threads my soul
take the road between the snowy moons,
take the road between the first morning
and the last night,
take the road between the pinch of lights
in the doryman's village,
but never take the road between your
 dreams . . .

—*GEORGE MENDOZA*

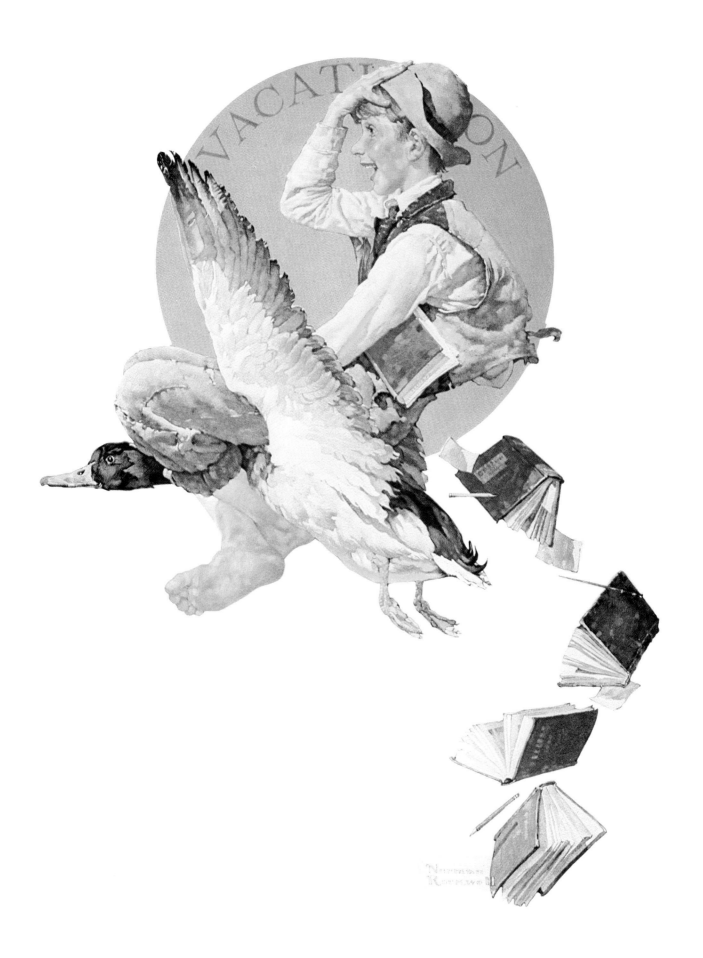

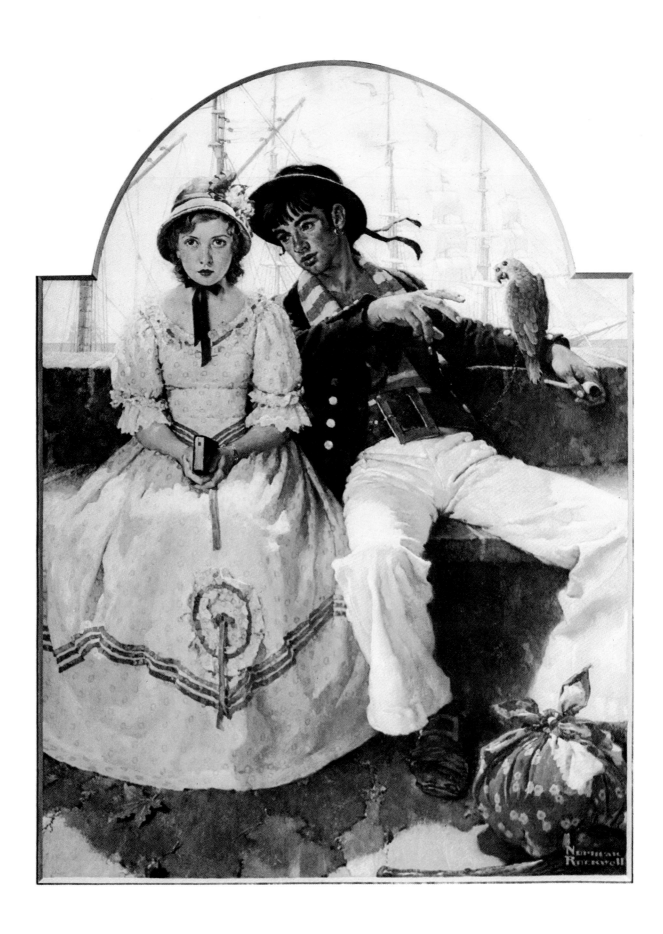

This for you is a little story, in size no greater than my shell, a sea shell found thrown up onto the shore one year a summer ago.

The shell was as smooth as the sea, as white as the snow clouds riding over the waves, all pink and pearl-deep inside her watery wells.

It was the most perfect, most beautifully sculpted shell I had ever held without a trace of scars that come from long journeys across the ocean floor.

And the swirls of sounds that came from inside its winding halls—ah—if you closed your eyes you suddenly found yourself drifting through the currents of the endless sea, drifting and being taken away by a world without time.

Cupped in the curved nest of my hand the shell felt as light as a speckled dove and I took it from its abandoned place and brought it back to the city with me.

How many times when I was weary with the empty sounds of people I would press my shell to my ear and let the inner heart springs of the ocean pump through me until I was filled with its salty and wandering songs.

How many times when I could no longer bear the machine mouths clogging the city streets I would lift my shell as though it were a magical gate to free me from sounds that smash dreams.

How many times, how many times when I could not walk the sandy foam or smell the moon's wash of tide, I found myself like a vagabond listening to the spinnings from my shell.

Oh we learn words so that we might understand each other but how much more I felt from the mirrors of sounds that came so gently, undefined, from the chambers of my shell.

In time my little shell began to fade. It no longer sang to me of songs from the Sargasso Sea or of moon shadows drifting in the Spanish coves of Galicia. It no longer carried me on its mysterious current beyond the graves of reality.

Now it was filled with honking and people screaming from the swelling crowd. It was filled with rumbles and the gnashing sounds from the streets. It had become possessed by words and fearful argument.

It was as though the spirit of my shell had died. I held it and thought you are like a bird without flight, mountains without echoes, a flower without the sweep of wind in your petals.

I tapped it. I shook it. I whistled into it. "Where have you gone?" I said. "Will you never return?"

I took my shell back to the sea where I had found it. I watched it toss for awhile in the quiet lace of waves. Then, slowly sinking under a wake of bubbles, it disappeared.

I have never heard from my shell again.

—GEORGE MENDOZA
"My Shell"

Boy was ten years old
when he got his pup,
my boy, Ryan.
Same eyes, same nose,
sad and full of lonely trusting
and would eat anything
but loved green apples
more than meat in the bowl.
One day I cut an apple
in thin slices and showed dog
the miracle of the star in the center
and inside the dark, polished seeds.
"A star!" I said. "Exactly!"
Dog ran off with the star,
sniffs heavenward ever since.

—GEORGE MENDOZA
"Ryan's pup"

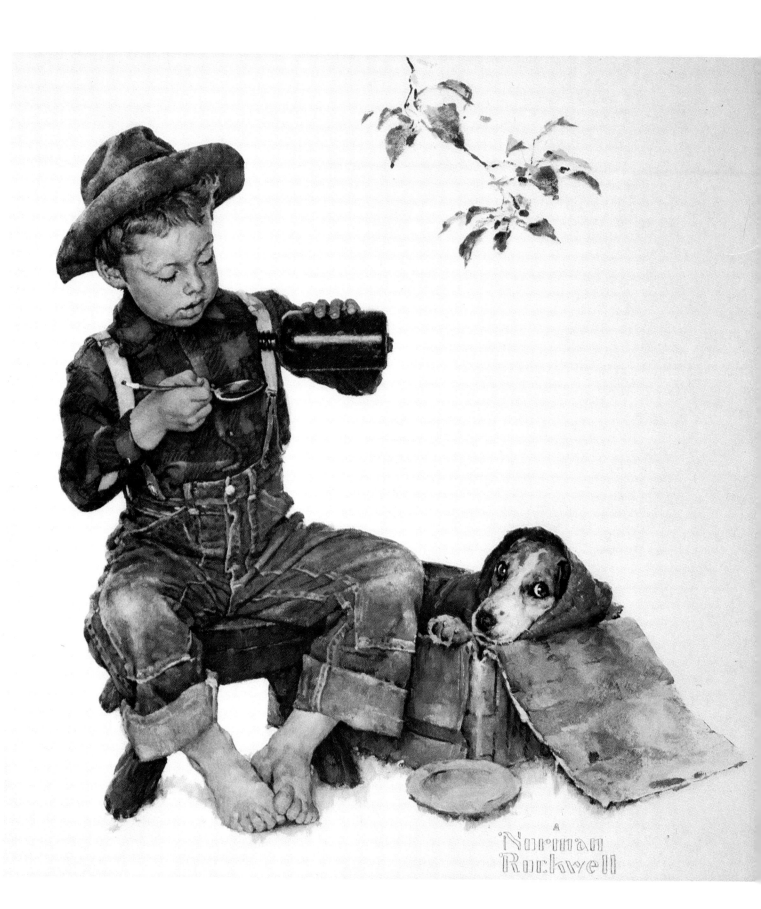

A lightning gleam:
 into darkness travels
 a night heron's scream.

—*MATSUO BASHŌ*
"Lightning at Night"

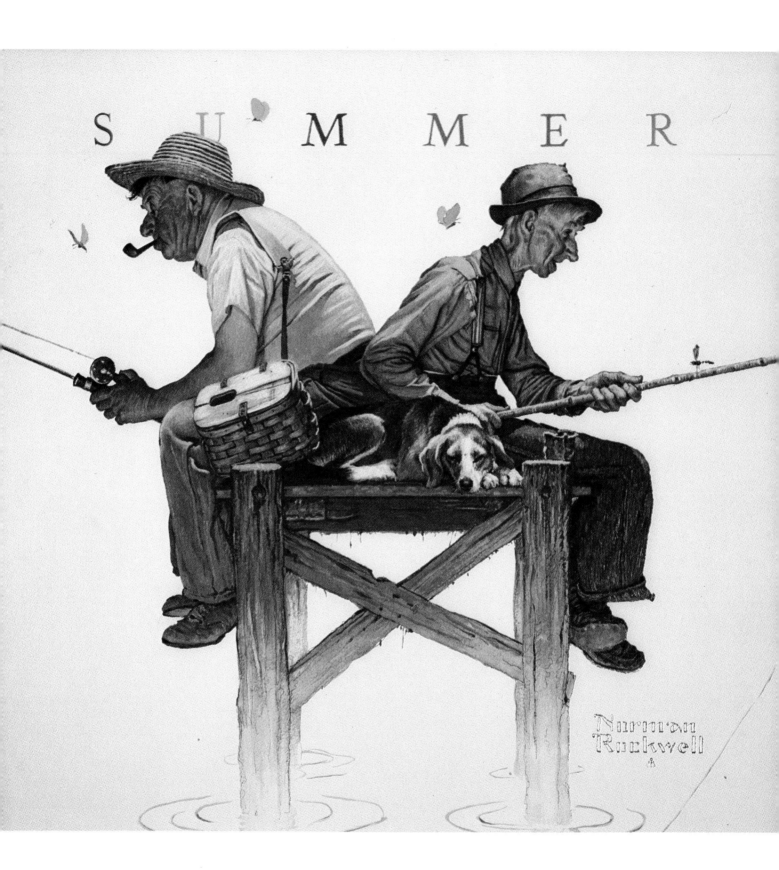

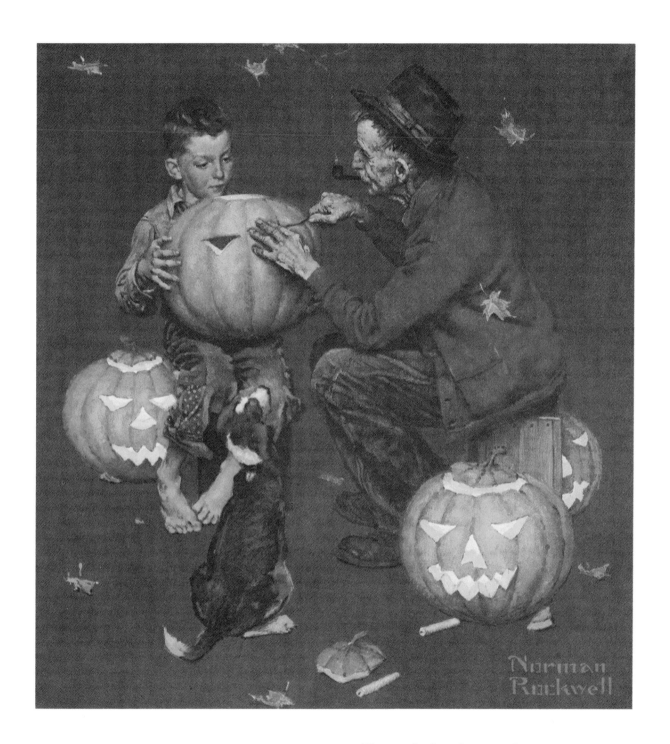

Through the shutters it came,
autumn's own shape: the warp
of the candle flame.

—RAIZAN
"Autumn"

Ask me what a poem is for
or what it should do
and I would tell you
go plough your hill
while I leave mine wild to grow.

—GEORGE MENDOZA

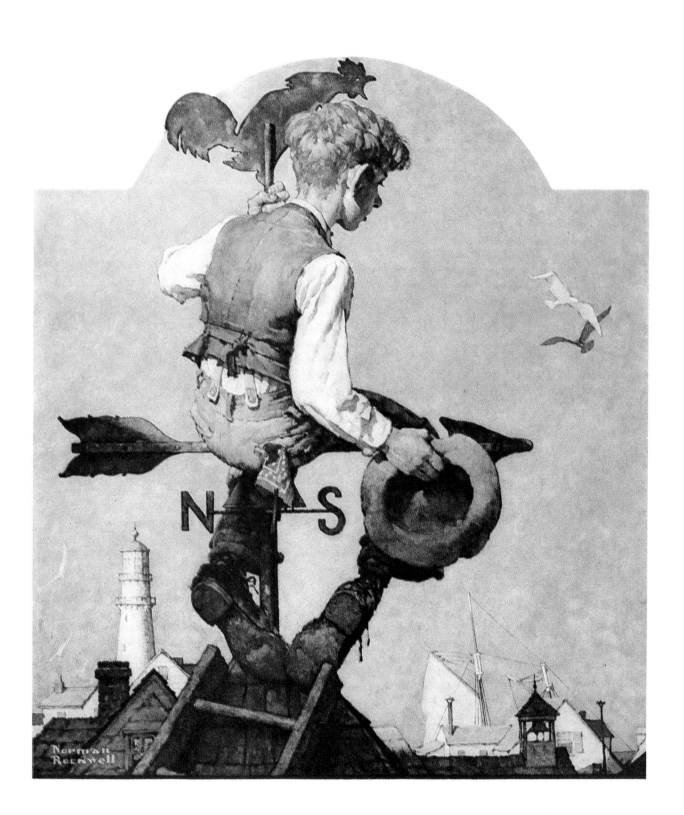

I'd like to see you get up here friend
to watch the night walk into the mountains,
to hear a bough brushing a window,
to smell a flower with the wind in its petals,
to touch the fever of the sky
when the red moon maddens the eye;
 time you got up here friend
 it's getting awful late.

 —*GEORGE MENDOZA*

The skinny kid
 leaped for the leaf;
 he thought he could catch it—
one green leaf.
It would fall in its own time
but now, wind-turning,
red-speckled with orange suns spinning,
green still running in its rivers,
it held the bough that bore it.
The skinny kid will kick it
in a week or so
if he has a mind to.

 —*GEORGE MENDOZA*

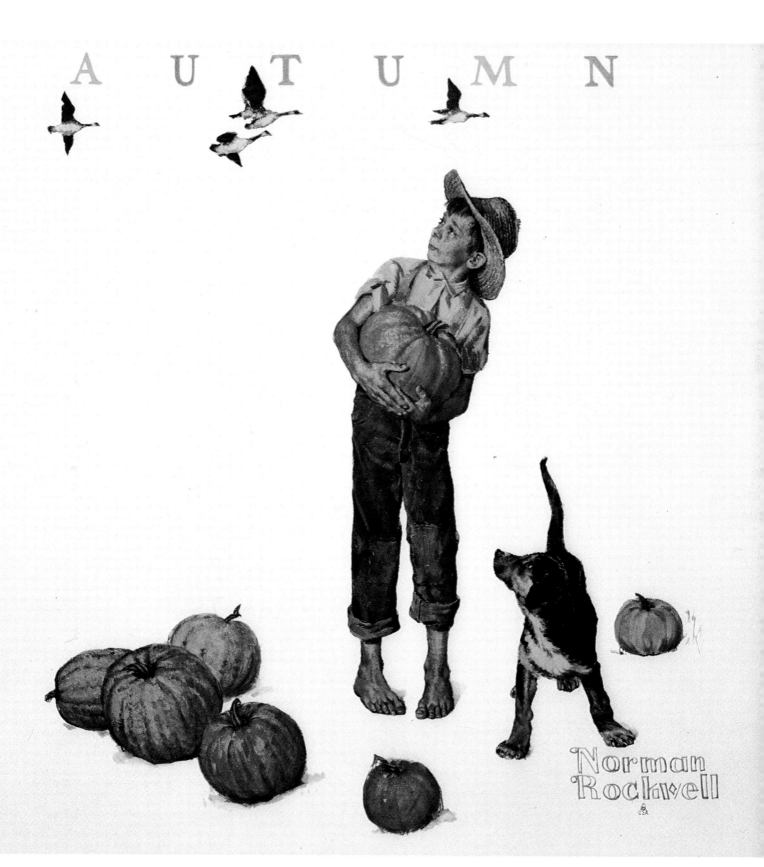

AUTUMN

Norman Rockwell

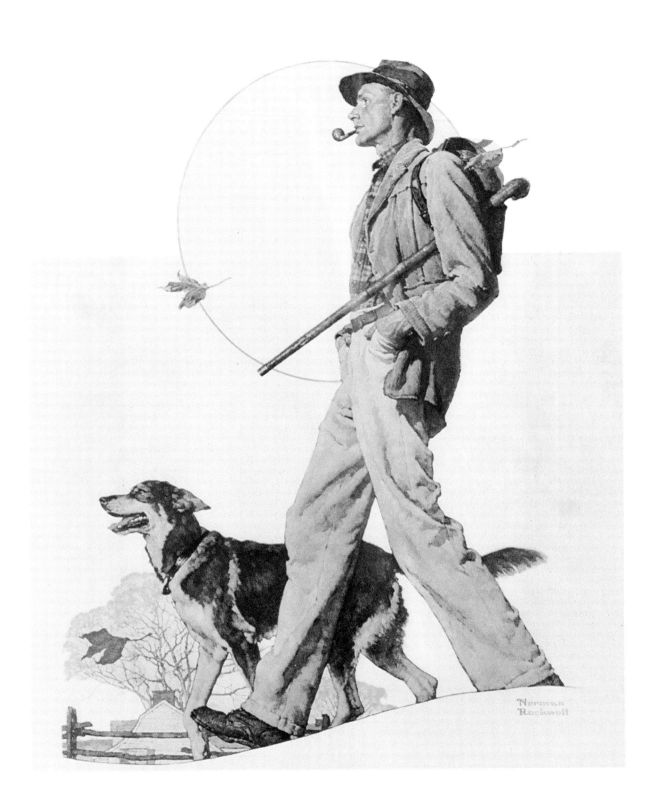

I come to this mystical brook-river
to escape awhile . . .
to take my drink as though I were a thief
with time . . .
to dream out dreams,
to cloud my head in clouds
tumbling down like milkweed suns,
to tie a speck of winged fly
to a leader silken as a fair girl's hair,
to walk across fresh-cut fields of rye and
 wheat
toward a stretch the poet Soper said
was fast and deep,
as sun-gold as the tasseled corn,
to talk to my poet friend
under a sickle of moon, with stars
dusting themselves
and spanning the yards of the dipper.
O let the world spin old
my dawn is sweet,
September cold—
The mist is creeping low,
like a serpent with its head under a rock,
and its tail still weaving in the grass.
On the brook before a flower opens
I'm casting by the dam,
old dam, weather-planked by the burned-
 down mill
where yellow butterflies flutter
above charred timbers
and wild trout lilies and boneset and mint
tilt like windmills by the stream
and clover balls pop like little plums
in the brush weed.

The smell of the brook is swimming in my
 head;
my soul reaches for a somewhere prayer.
I know the lunkers are nymphing from the
 deeps,
but before the morning wind is up
I'll be wandering like a gypsy boy
down the stretch below,
where the white house high on the birch bank
peeps through the pealing trees,
where all the river bends like a bough
and the alder leaves drop in the laughing
 furrows
to ride and play beside my fly.

—GEORGE MENDOZA
"As Though I Were a Thief with Time"

I walked across a meadow and two
through the walls of evening sky
where the high hills
hung like huge coal chunks
and the grasses were singing, dark singing,
and the quail at my feet
suddenly exploded out of the nest of my heart
and went winging, far winging . . .

—GEORGE MENDOZA

This is the place he had disappeared:
he had waded through the meadow
of grasses
beneath a fair, star-flowered night.
Plunging through grasses grown taller
than his years
he had never seen the sudden drop
down to the silt-mud of the oxbow brook.
He was never found; but he was talked about
by waitresses in roadstops for a few days.

—GEORGE MENDOZA
"The Oxbow"

Season of mists and mellow fruitfulness,
　Close bosom-friend of the maturing sun:
Conspiring with him how to load and bless
　With fruit the vines that round the thatch-
　　eves run;
To bend with apples the mossed cottage-
　　trees,
　And fill all fruit with ripeness to the core;
　　To swell the gourd, and plump the hazel
　　shells
With a sweet kernel; to set budding more,
　And still more, later flowers for the bees,
　Until they think warm days will never
　　cease,
　　For Summer has o'er-brimmed their
　　clammy cells.

Who hath not seen thee oft amid thy store?
　Sometimes whoever seeks abroad may find
Thee sitting careless on a granary floor,
　Thy hair soft-lifted by the winnowing wind;
Or on a half-reaped furrow sound asleep,
　Drowsed with the fume of poppies, while
　　thy hook
　　Spares the next swath and all its twinèd
　　flowers:
And sometimes like a gleaner thou dost keep
　Steady thy laden head across a brook;
　Or by a cider-press, with patient look,
　　Thou watchest the last oozings hours by
　　hours.

Where are the songs of Spring? Ay, where are
　they?
Think not of them, thou hast thy music too,—
While barred clouds bloom the soft-dying day,
And touch the stubble-plains with rosy hue;
Then in a wailful choir the small gnats mourn
Among the silver sallows, bourne aloft
Or sinking as the light wind lives or dies;
And full-grown lambs loud bleat from hilly
　bourn;
Hedge-crickets sing; and now with treble soft
The redbreast whistles from a garden-croft,
And gathering swallows twitter in the skies.

—JOHN KEATS
"To Autumn"

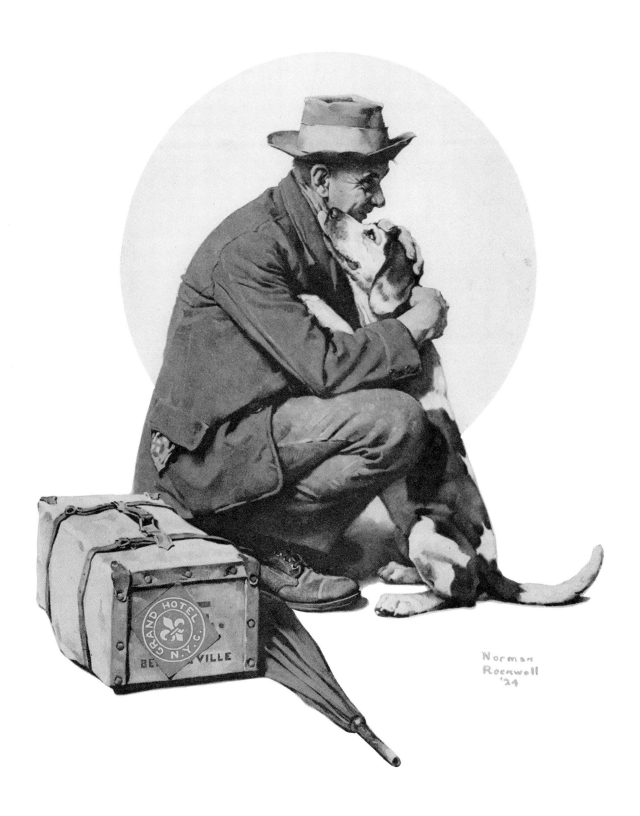

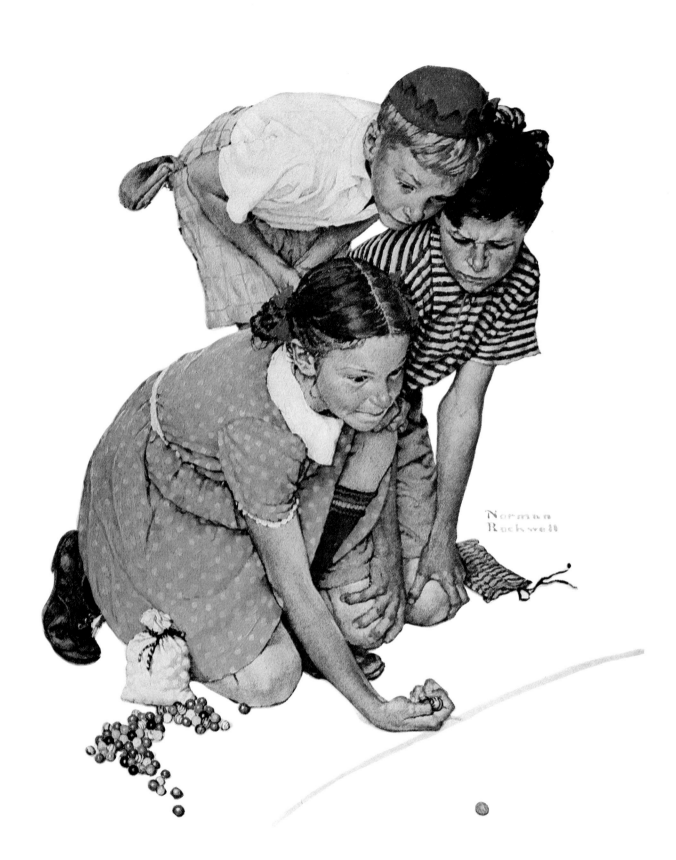

the day is falling
like the rain
only the gravel puddles
are filling treasures
under the slanting lights . . .

—*GEORGE MENDOZA*

Beyond the shelf of cobwebbed bottles
lies the forest, dark in sun-green.
Through old bottles, bubble-cracked,
the forest splinters
in a sea of pine-boughs,
webbing the wind,
blurring old bottles like old eyes.

—GEORGE MENDOZA
"Old Bottles, Missing Corks"

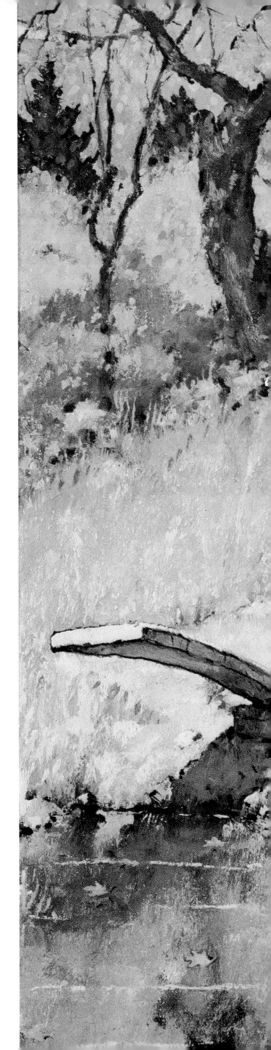

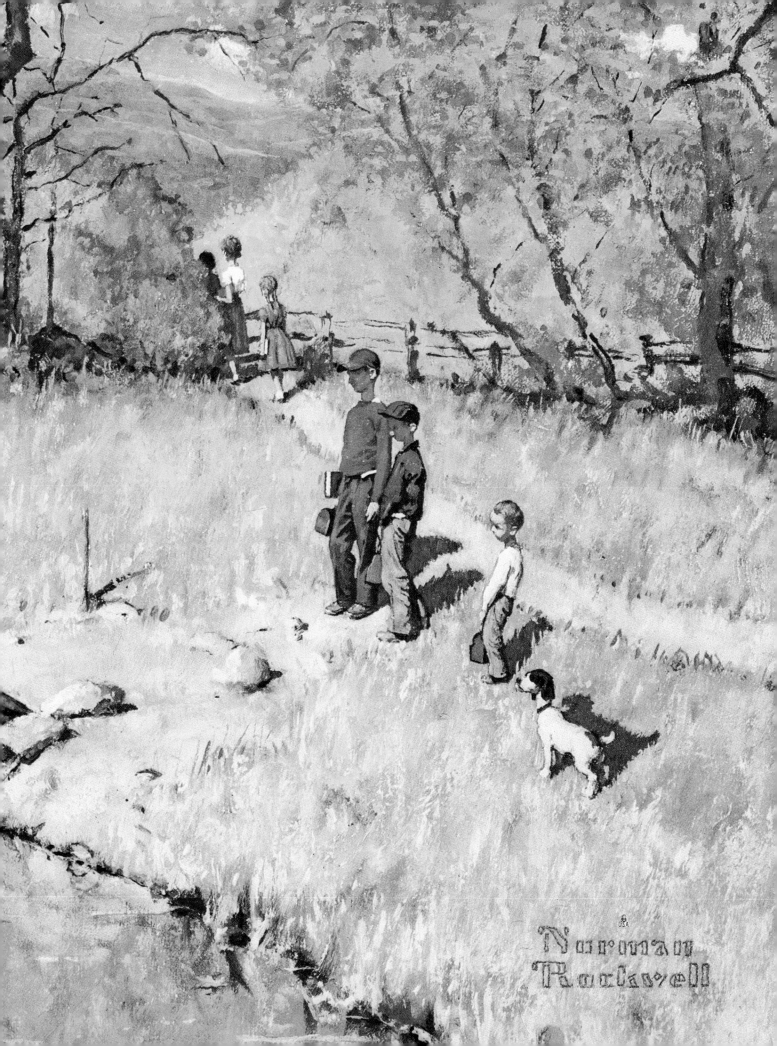

pond of blue light
hammering into the leaves of dream-dusk
a farmhouse glows at the foot of the
 mountain
like a hunter's fire . . .
a boy is spinning a liverish worm
upon the pond of blue light . . .

 —GEORGE MENDOZA

I stood in the wind
and tried to capture it.
But when I saw the butterfly
flying flat and low—
I let the wind go,
I let it go.

 —GEORGE MENDOZA

In the night's one-eye
the corn moon melts through the Indian
 peaks
tiling the river's flat runs
with silver weed mist
and the bats are swooping
like toy airplanes
launched from the pad of a child's pillow . . .

 —GEORGE MENDOZA

Into the river came all streams clear tumbling
Into the river came a boy alone wishing
Into the river came a bird high singing
Into the river came a flower wild floating
Into the river came a fish night plucking
Into the river came a man pure dreaming
O where is the river now that nets the moon
 falling?

 —GEORGE MENDOZA

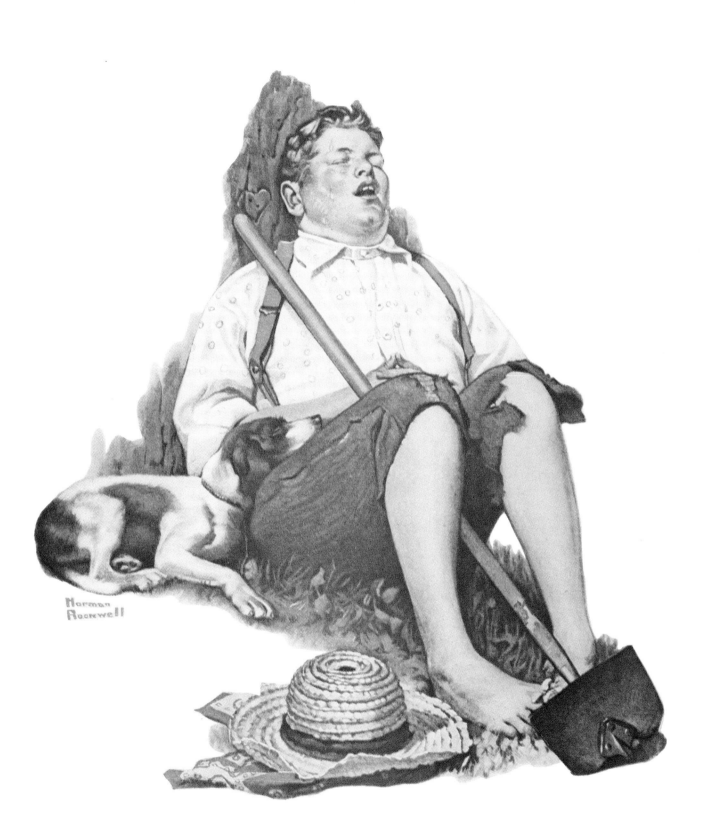

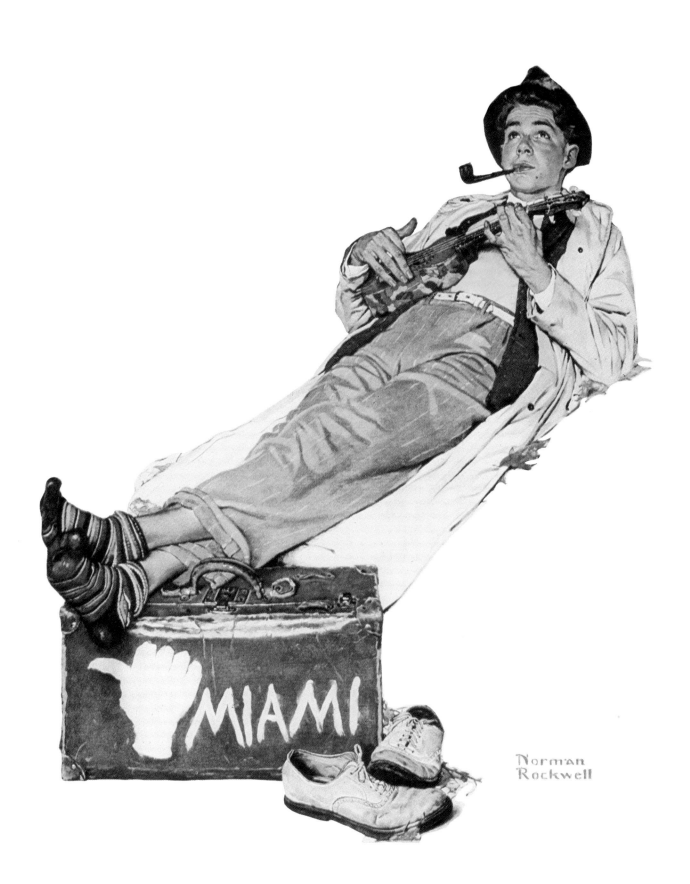

Come, stay with me
once more by this rock
let the river rove
through the pulley of pearl stones
let it lap in the brush-holes
of cavelike, sunken stumps—
let it set the spring of all dreams
again once high—
O catch the red leaf coming
before it travels by . . .

—*GEORGE MENDOZA*

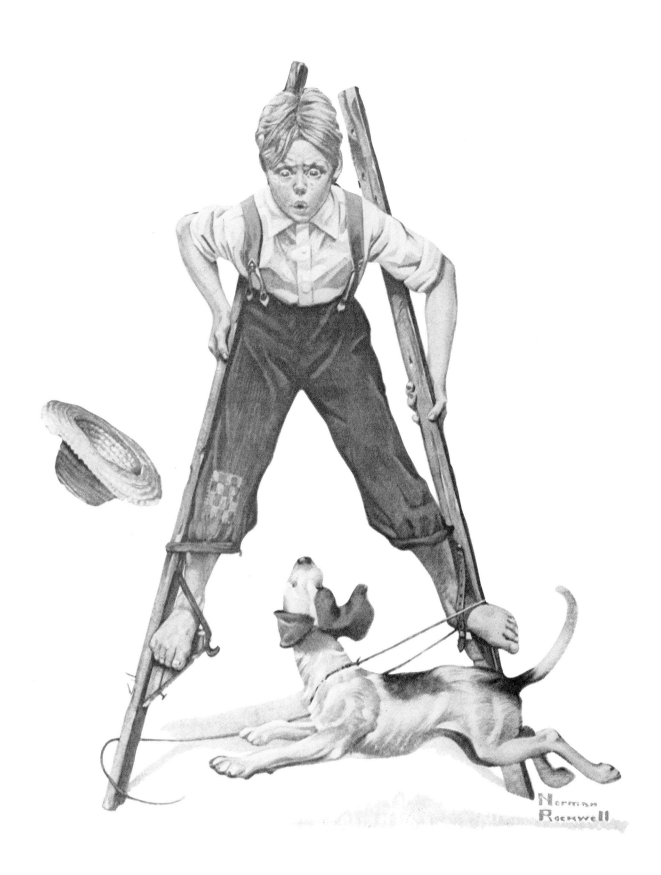

Over the bridge
on the high night-bank
in the black feathers of leaves
the war raged—
Needles of fire crackled the air
like dry logs spitting against a screen
an owl swooped through the star-bursts
without sound, his wings like a dark snow,
as the fireflies lighted his way.

<div align="right">

—GEORGE MENDOZA
"Vermont images"

</div>

Look up
I said to the child
through the willow
into the wells of sky
let the river-boughs
carry you
through the onion-leaves
swirling like minnow-islands
round the last sun-shafts . . .

O my evening sea is coming
it begins to grow cold
in the currents of September
Look up
I said to the child
soon we must go home.

<div align="right">

—GEORGE MENDOZA

</div>

The garden's grown over
like a high seaweed tide
the corn never took
but the orange carrot barrels
were endless earthly invasions—
the lettuce curled and bunched tight,
luring grasshoppers into leafy inns
far from the hunters of the night—
and poppies and poppies and poppies
came rising like purple ocean moons
till their petals fell
under the glide of fall.

 —GEORGE MENDOZA

no more the plum sweeps
and the yellow dips
across the split-railed road
no more the wind-clouds
horsing down the distant hills
no more the willow
driving through my head
no more the sun cliffs
scooping the hollow green
or the slate running mountains
that once said:
you're home, old stranger, you're home—
no more, no more
for the Thru-way is carved
in the trenches of my eyes.

 —GEORGE MENDOZA

The outside lamp is an hourglass
of dead moths—
Five months now we've been here
passersby in a sweet-pea cottage
with gumdrop poppies and maple in the
 chimney smoke
while the moths were gorging deep
round the buoy of the squatting forty watt.
I should empty them, I know.
But the crayon wings and crumbling bodies
 mixed
are a marker of the summer's depth . . .
The owner of the little house
at the end of the road
will remove them when we're gone.
And he will ponder:
how faulty a man can be!

 —GEORGE MENDOZA

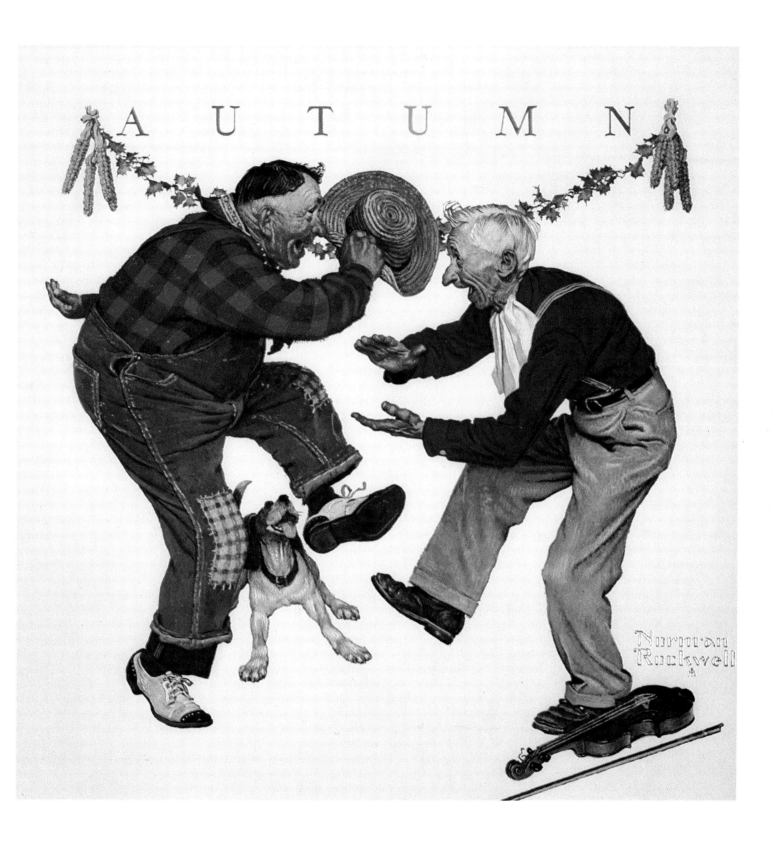

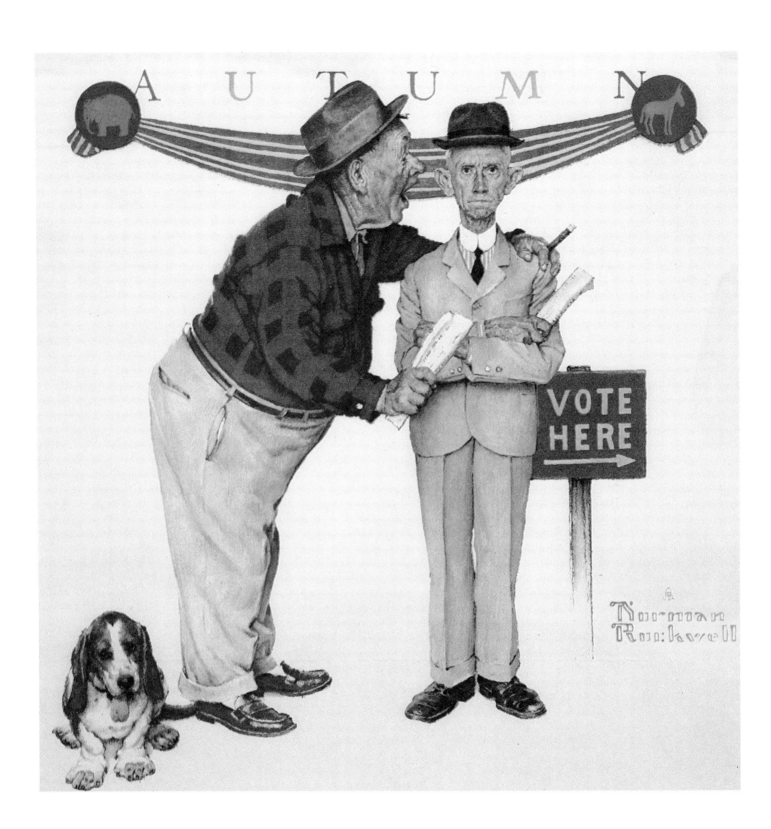

it was the last weekend to stream
the breadcrust, the fishhawk, the dream blue
"those are the flies I'm going to wet . . ."
said the man in the cobwebbed fishing shack.
". . . and if I don't catch anything . . . that's
 all right too . . .
the fish can go hungry . . ."

—GEORGE MENDOZA
"Vermont Logic: September 1970"

It was a little shack by a river
with a brick rust chimney singing out a
 slate roof.
It was a place a man could go
to escape the slashing world . . .
where he waited for nothing more
than a metal coffee pot to whistle from a
 wood stove . . .
while the winds from the forest of pine flows
crossed the deer-run banks
and smoked all day in your head . . .

I drove a September Sunday to see my friend
who owns the little shack by the river
to share river spinning in some coffee—
but when I reached his cedar door
a sign scrawled out at me:
"ON VACATION. GONE TWO WEEKS.
 AL."

—GEORGE MENDOZA
"Vermont Logic: September 18, 1970"

Unseasonable
as bees in April,
rime in May,
or Orion high
in June,
 days lost
somewhere in August,
green days, dun,
return at noon
as numb-winged wasps
swim in the lapse
of weather:
 sun
and weathervane
are still; the cows
wait, hillside crows
caw down to barn
the first-frost burn
of sumac, maple,
and sideyard apple.
The sky is halo-
hazed, barn and silo
smell of baled hay,
corn-crib, and dry
harvest days;
 days,
goldenrod days:
and the dazzled wasps
climb numb in the lapse
of weather, lost
in what cannot last,
wings struck dumb,
in this other summer,
summer twice come.

 —PHILIP BOOTH
 "Vermont: Indian Summer"

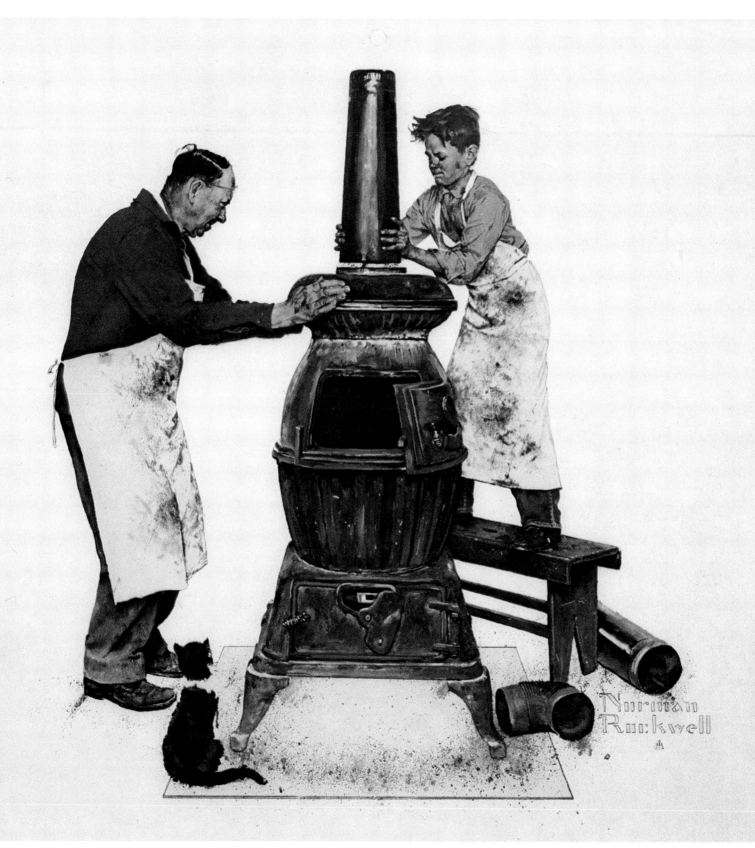

When I'm with you
I'm like a blue and yellow glider
sailing between the cliffs of stars
playing Ping-Pong with the planets
fingerpainting across fields of air
gliding like a golden leaf
in the silver streams of the night.

When I'm with you
I'm like a child's clock
where once upon a time
turns itself around
and galaxies spin the game of twirling jacks
and moons like tangerine fish
are falling, falling
in a boyhood well
of penny wishes.

When I'm with you
I'm like a dream,
a dream within another world
where the Milky Way
is a song of bridges
spanning the moats of space
where constellations are crystal carousels
and the Little Dipper
is an angel's arrangement
of potted daffodils.

—GEORGE MENDOZA
"When I'm with You"

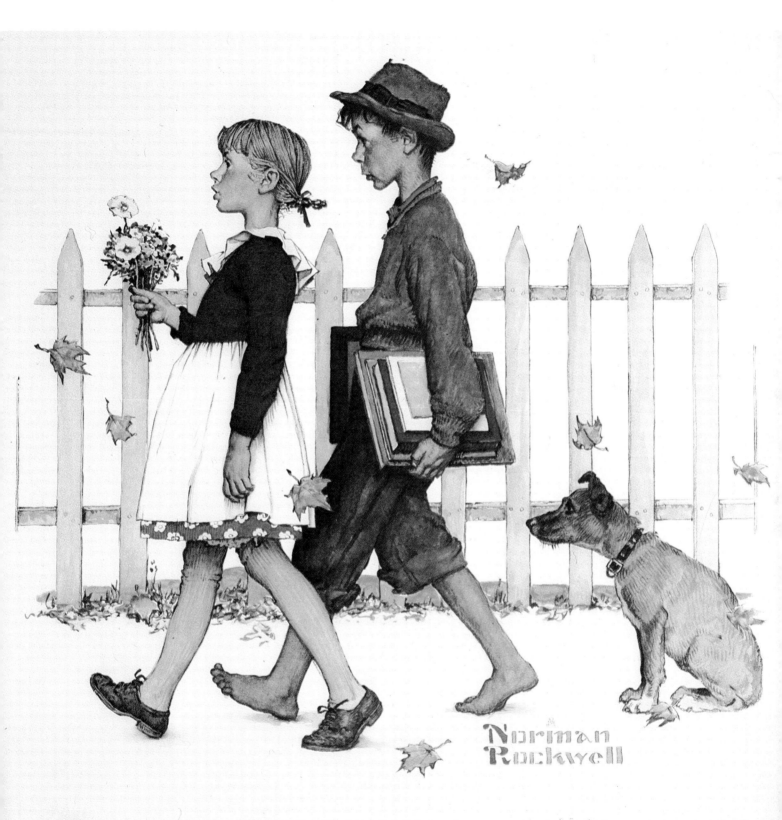

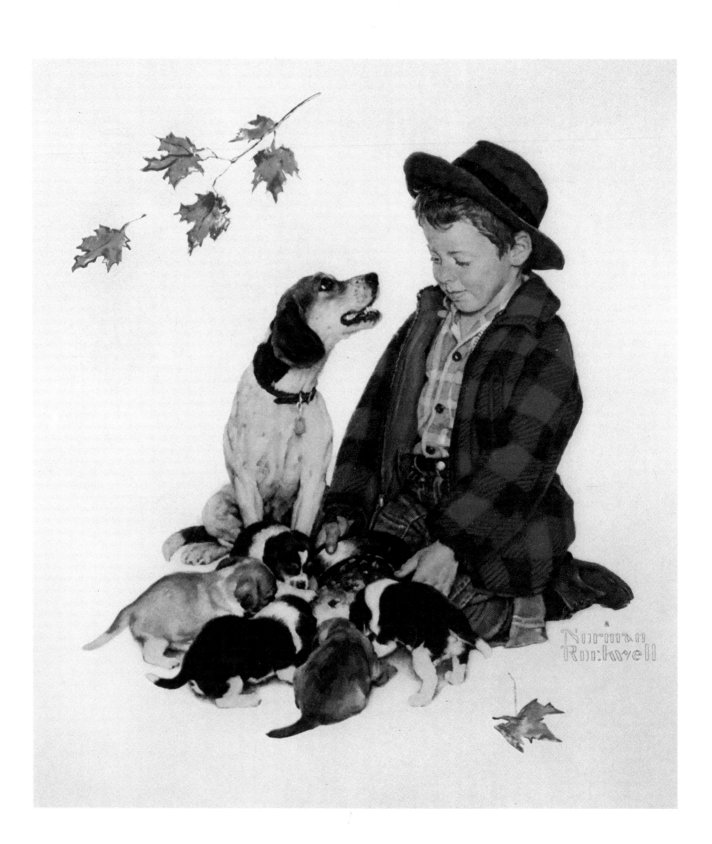

The goldenrod is yellow,
 The corn is turning brown,
The trees in apple orchards
 With fruit are bending down.

The gentian's bluest fringes
 Are curling in the sun;
In dusty pods the milkweed
 Its hidden silk has spun;

The sedges flaunt their harvest
 In every meadow nook,
And asters by the brookside
 Make asters in the brook;

From dewy lanes at morning
 The grapes' sweet odors rise;
At noon the roads all flutter
 With yellow butterflies—

By all these lovely tokens
 September days are here,
With summer's best of weather
 And autumn's best of cheer.

—HELEN HUNT JACKSON
"September"

One by one, like leaves from a tree,
All my faiths have forsaken me;
But the stars above my head
Burn in white and delicate red,
And beneath my feet the earth
Brings the sturdy grass to birth.
I who was content to be
But a silken-singing tree,
But a rustle of delight
In the wistful heart of night—
I have lost the leaves that knew
Touch of rain and weight of dew.
Blinded by a leafy crown,
I looked neither up nor down—
But the little leaves that die
Have left me room to see the sky;
Now for the first time I know
Stars above and earth below.

—SARA TEASDALE
"Leaves"

O hushed October morning mild,
Thy leaves have ripened to the fall;
Tomorrow's wind, if it be wild,
Should waste them all.
The crows above the forest call;
Tomorrow they may form and go.
O hushed October morning mild,
Begin the hours of this day slow.
Make the day seem to us less brief.
Hearts not averse to being beguiled,
Beguile us in the way you know.
Release one leaf at break of day;
At noon release another leaf;
One from our trees, one far away.
Retard the sun with gentle mist;
Enchant the land with amethyst.
Slow, slow!
For the grapes' sake, if they were all,
Whose leaves already are burnt with frost,
Whose clustered fruit must else be lost—
For the grapes' sake along the wall.

—ROBERT FROST
"October"

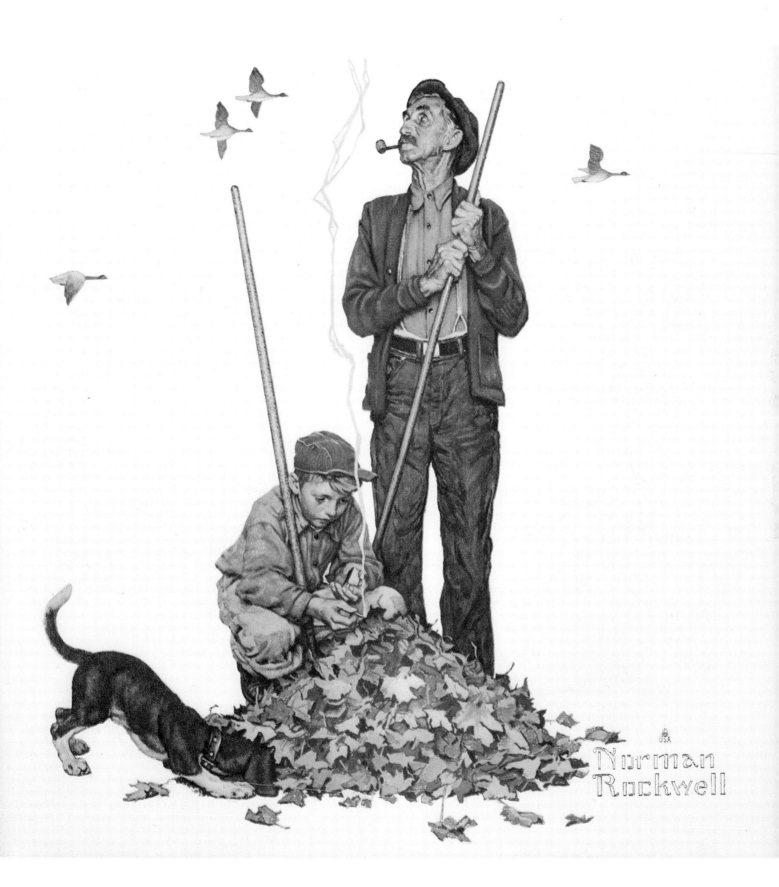

The morns are meeker than they were,
The nuts are getting brown;
The berry's cheek is plumper,
The rose is out of town.

The maple wears a gayer scarf,
The field a scarlet gown.
Lest I should be old-fashioned,
I'll put a trinket on.

<div align="center">

—*EMILY DICKINSON*
"Autumn"

</div>

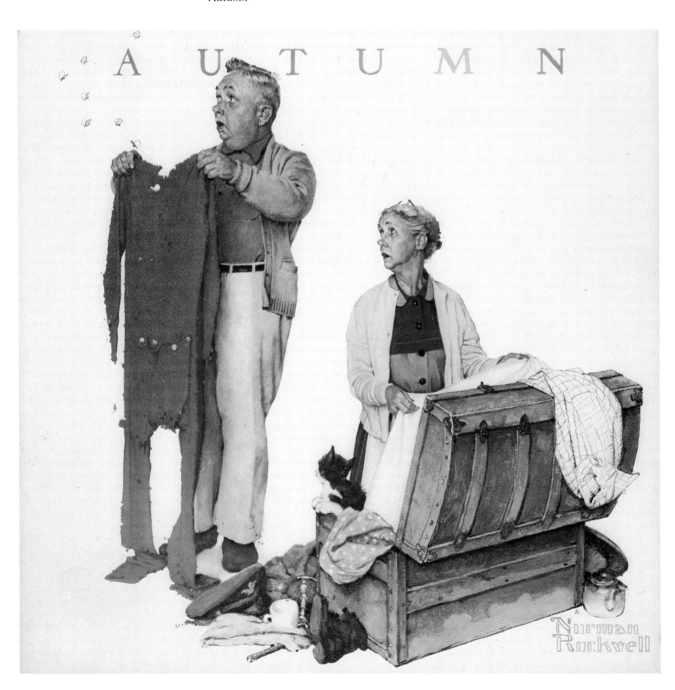

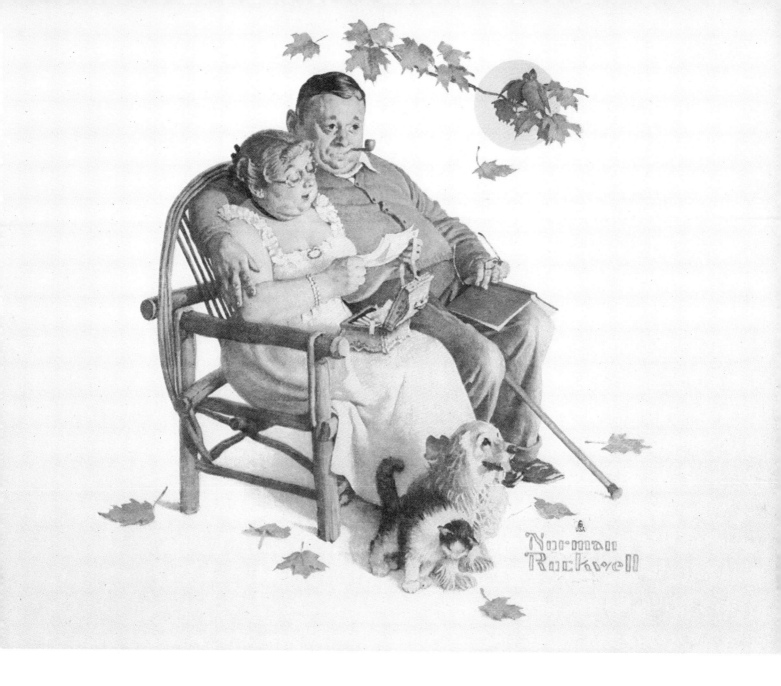

Where did you think I would bring you?
Under a bridge, beside a tree?
River flowing in a birch peeling canoe?

Where did you think I would bring you?
On top a hill closest hill to heaven?
Clover in your hair,
honey sapping my fingers.

Where did you think I would bring you?
To my windows under water over the garden
I brought you, fished for love with you.
And our hearts were creels to hold our catch.

Of all places where had your dreams sent
 you?

—GEORGE MENDOZA

Along the line of smoky hills
 The crimson forest stands,
And all the day the blue-jay calls
 Throughout the autumn lands.

Now by the brook the maple leans
 With all his glory spread,
And all the sumachs on the hills
 Have turned their green to red.

Now by great marshes wrapt in mist,
 Or past some river's mouth,
Throughout the long, still autumn day
 Wild birds are flying south.

 —*WILFRED CAMPBELL*
 "Indian Summer"

When I was a boy,
barely tall,
I shot a sparrow from a tree.
I held its limp body in my hands
and buried it still warm in the soft earth.
Then I fled.
I never touched a gun again.
But years came later when I was a man
I wondered,
oh, the hunter I might have been
had I but met a lion that first day
and not stilled that gentle sparrow's call.

 —*GEORGE MENDOZA*
 "The Hunter I Might Have Been"

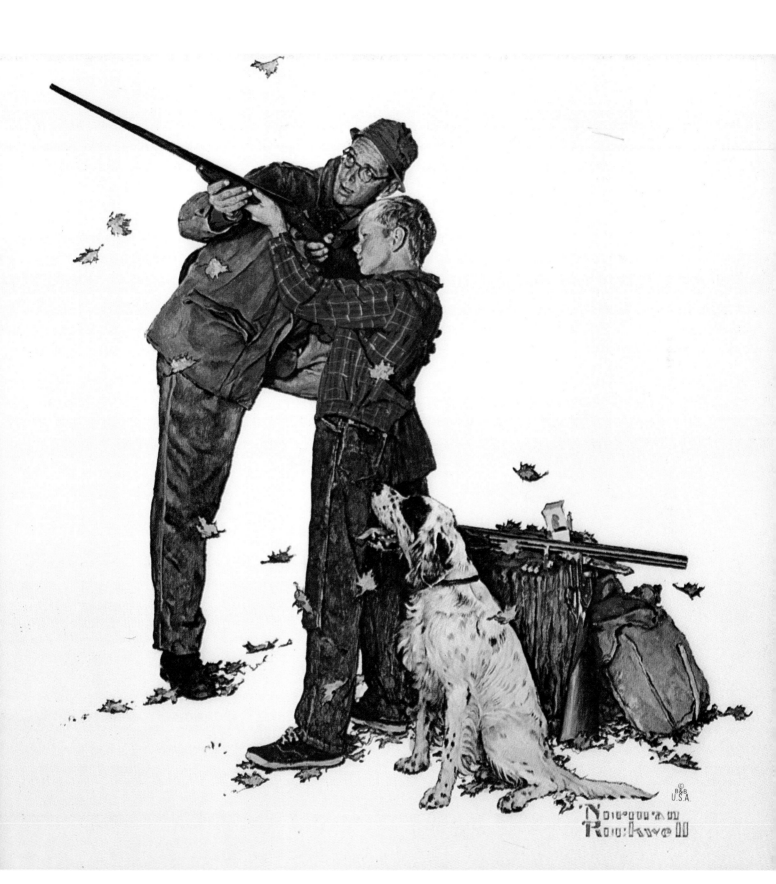

You were born in Chicago,
were you stranger?
You were born in Ohio,
were you stranger?
You were born in Texas,
were you stranger?
If you didn't know where you were born,
you wouldn't be a stranger.
You'd be a flute player
looking for the back of a tree.
You'd be a poet spinner
flying with a yellow finch.
You'd be a lean and handsome lover
loving every loving thing.

—GEORGE MENDOZA

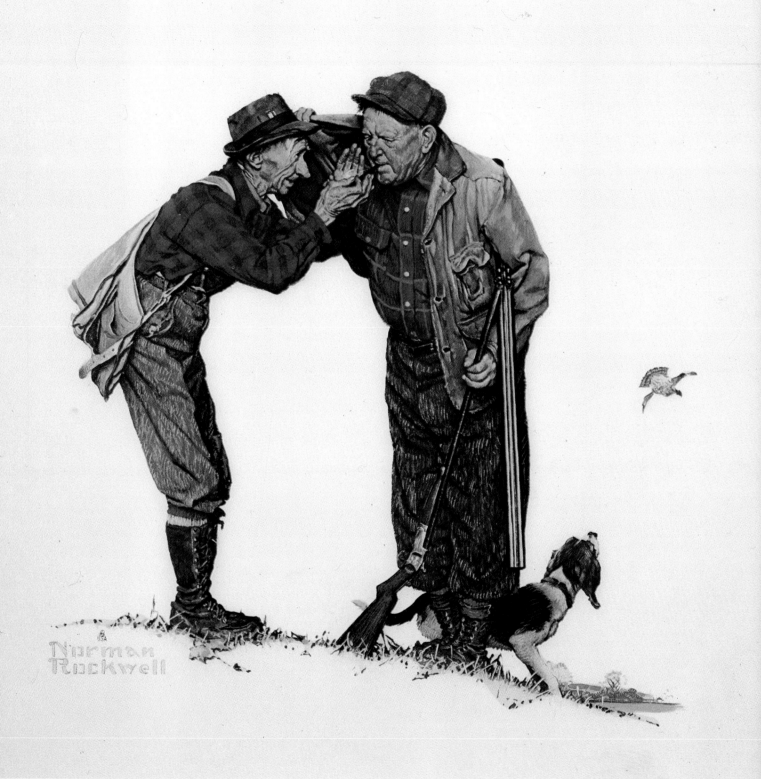

Give to me the life I love,
Let the lave go by me,
Give the jolly heaven above
And the byway nigh me.
Bed in the bush with stars to see,
Bread I dip in the river—
There's the life for a man like me,
There's the life for ever.

Let the blow fall soon or late,
Let what will be o'er me;
Give the face of earth around
And the road before me.
Wealth I seek not, hope nor love,
Nor a friend to know me;
All I seek, the heaven above
And the road below me.

Or let the autumn fall on me
Where afield I linger,
Silencing the bird on tree,
Biting the blue finger:
White as meal the frosty field—
Warm the fireside haven—
Not to autumn will I yield,
Not to winter even!

Let the blow fall soon or late,
Let what will be o'er me;
Give the face of earth around
And the road before me.
Wealth I ask not, hope nor love,
Nor a friend to know me;
All I ask, the heaven above,
And the road below me.

—ROBERT LOUIS STEVENSON
"The Vagabond"

My Sorrow, when she's here with me;
 Thinks these dark days of autumn rain
Are beautiful as days can be;
She loves the bare, the withered tree;
 She walks the sodden pasture lane.

Her pleasure will not let me stay.
 She talks and I am fain to list:
She's glad the birds are gone away,
She's glad her simple worsted gray
 Is silver now with clinging mist.

The desolate deserted trees,
 The faded earth, the heavy sky,
The beauties she so truly sees,
She thinks I have no eye for these,
 And vexes me for reason why.

Not yesterday I learned to know
 The love of bare November days
Before the coming of the snow,
But it were vain to tell her so,
 And they are better for her praise.

—ROBERT FROST
"My November Guest"

Red o'er the forest peers the setting sun;
 The line of yellow light dies fast away
That crown'd the eastern copse; and chill and
 dun
 Falls on the moor the brief November day.

Now the tired hunter winds a parting note,
 And Echo bids good-night from every
 glade;
Yet wait awhile and see the calm leaves float
 Each to his rest beneath their parent shade.

How like decaying life they seem to glide
 And yet no second spring have they in
 store;
And where they fall, forgotten to abide
 Is all their portion, and they ask no more.

Soon o'er their heads blithe April airs shall
 sing,
 A thousand wild-flowers round them shall
 unfold,
The green buds glisten in the dews of Spring,
 And all be vernal rapture as of old.

Unconscious they in waste oblivion lie,
 In all the world of busy life around
No thought of them—in all the bounteous sky
 No drop, for them, of kindly influence
 found.

Man's portion is to die and rise again:
 Yet he complains, while these
 unmurmuring part
With their sweet lives, as pure from sin and
 stain
 As his when Eden held his virgin heart.

—JOHN KEBLE
"November"

That time of year thou mayst in me behold
When yellow leaves, or none, or few, do hang
Upon those boughs which shake against the
 cold,
Bare ruined choirs where late the sweet birds
 sang.
In me thou seest the twilight of such day
As after sunset fadeth in the west
Which by and by black night doth take away,
Death's second self, that seals up all in rest.
In me thou seest the glowing of such fire,
That on the ashes of his youth doth lie
As the deathbed whereon it must expire,
Consumed with that which it was nourished by.
 This thou perceivest, which makes thy
 love more strong,
 To love that well which thou must leave
 ere long.

—WILLIAM SHAKESPEARE
"That Time of Year"

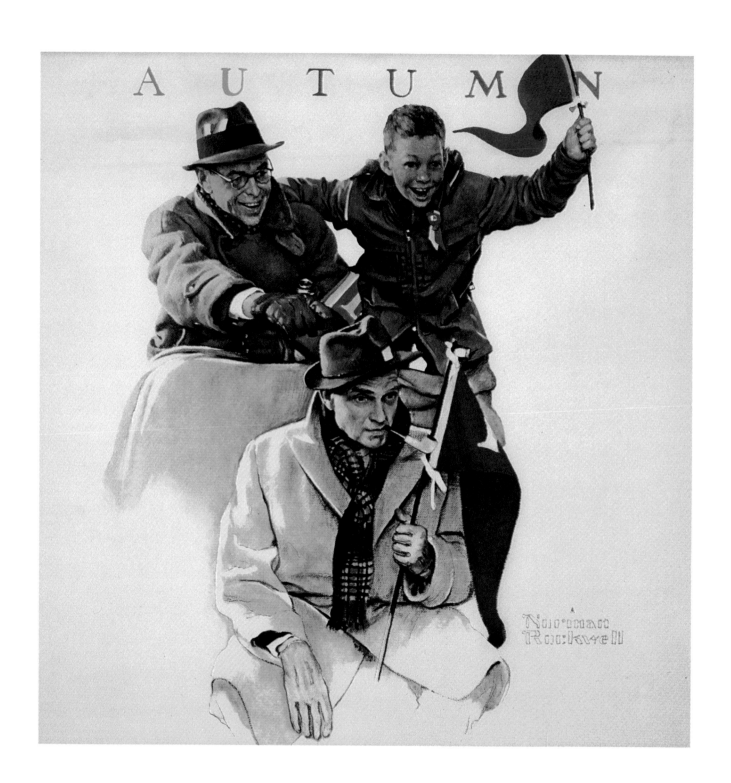

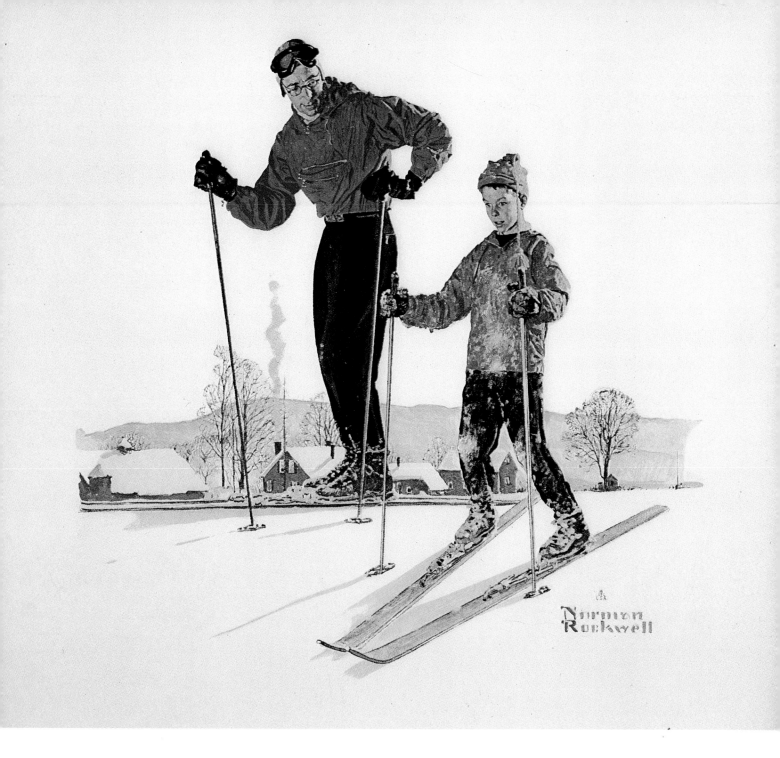

A mountain village:
 under the piled-up snow
 the sound of water.

 —SHIKI
 "Winter"

Well then, let's go—
 to the place where we tumble down
 looking at snow!

 —MATSUO BASHŌ
 "The Way of Zen"

Something is going to happen, I tell you I
 know.
This morning, I tell you, I saw ice in the
 bucket.
Something is going to happen and you can't
 duck it.
The way the wind blows is the way the dead
 leaves go.
Something is going to happen, and I'm telling
 you so.

Something is going to happen, I declare it.
It always happens on days like this, Mother
 said.
No, I didn't make the world, or make apples
 red,
But if you're a man you'll buck up and try to
 bear it.
For this morning the sun rose in the east, I
 swear it.

—ROBERT PENN WARREN

I remember only one Christmas,
 one Christmas as a boy.
 The fields were heavy white,
the river ice-chunked, frozen.
The huge stone house buried in kingly trees
atop the hill high with gleaming snow dunes.
That snow-filled spruce we cut,
my father and I,
flickering through the wide window
so many lights and dancing colors
flying to eternity.
I don't remember the toys,
only the gladness of that evening
one Christmas as a boy.

—GEORGE MENDOZA

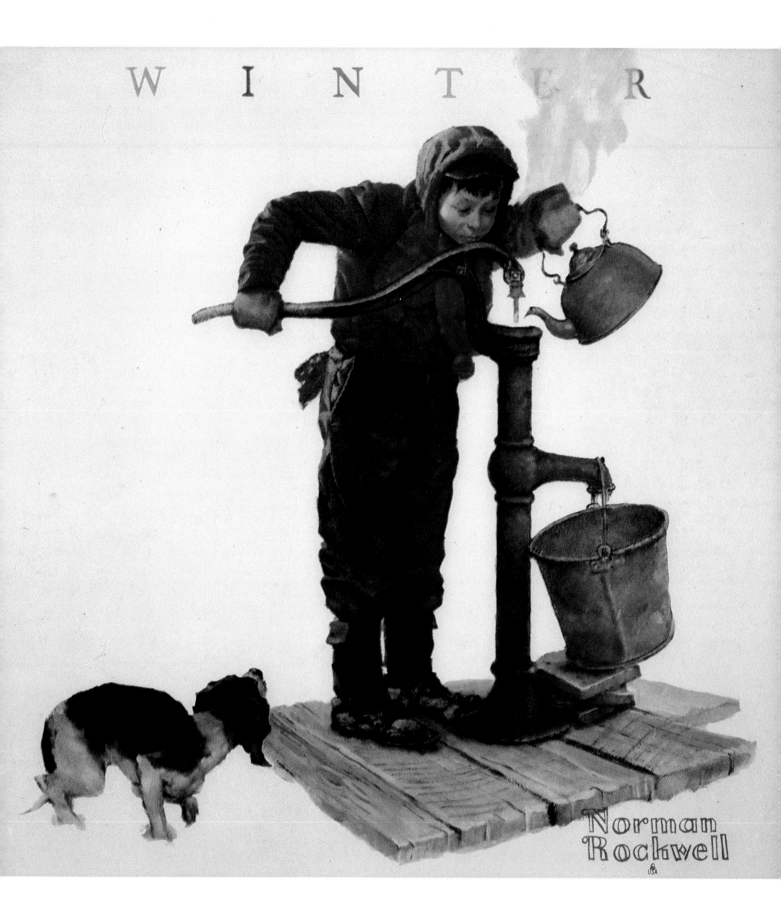

WINTER

Norman
Rockwell

One must have a mind of winter
To regard the frost and the boughs
Of the pine-trees crusted with snow;

And have been cold a long time
To behold the junipers shagged with ice,
The spruces rough in the distant glitter

Of the January sun; and not to think
Of any misery in the sound of the wind,
In the sound of a few leaves,

Which is the sound of the land
Full of the same wind
That is blowing in the same bare place

For the listener, who listens in the snow,
And, nothing himself, beholds
Nothing that is not there and the nothing
 that is.

 —WALLACE STEVENS
 "The Snow Man"

When icicles hang by the wall,
 And Dick the shepherd blows his nail,
And Tom bears logs into the hall,
 And milk comes frozen home in pail,
When blood is nipp'd and ways be foul,
Then nightly sings the staring owl,
 Tu-whit;
Tu-who, a merry note,
While greasy Joan doth keel the pot.

When all aloud the wind doth blow,
 And coughing drowns the parson's saw,
And birds sit brooding in the snow,
 And Marion's nose looks red and raw,
When roasted crabs hiss in the bowl,
Then nightly sings the staring owl,
 Tu-whit;
Tu-who, a merry note,
While greasy Joan doth keel the pot.

 —WILLIAM SHAKESPEARE
 "Winter"

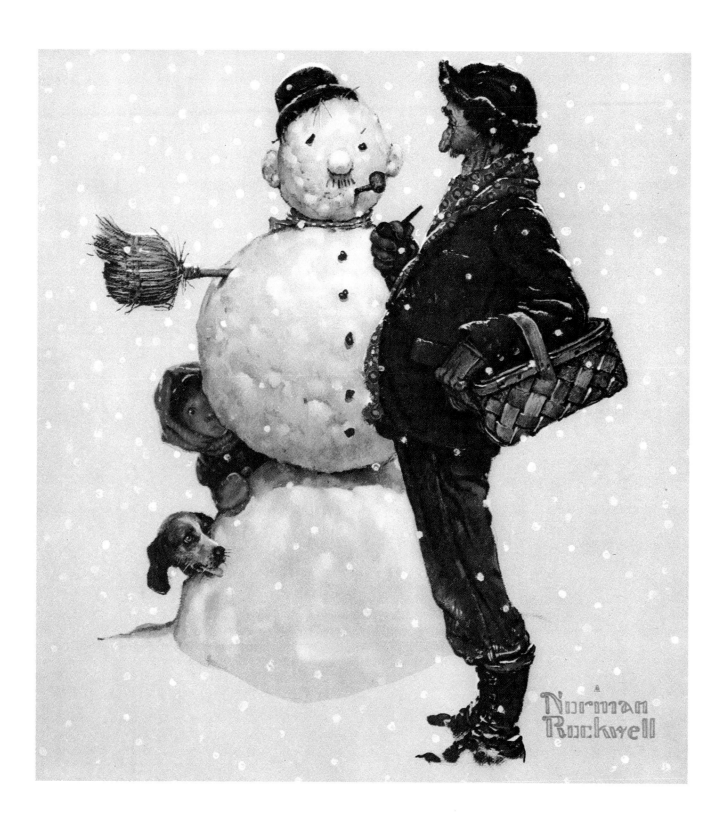

The river was cold
and blue,
the weather had turned
suddenly—
I knew it would snow.
My hands were red
like an autumn leaf.
Soon everything must die,
I thought.
The stones of the Boulder River
were clean and white
like skulls of snow.
The mountain spilled icy winds
upon me,
a branch cracked, on the peaks
a coyote howled and howled again.
A trout struck my hook.
My line went shooting out
Across the length of the river.
He felt like a giant among trouts
as he fought for distance
against a fisherman.
He filled my net
beginning to fill with snow.
You will come back,
I said,
and I will come back
like flowers,
the first in spring.
I looked up
and the world was falling white,
a net around me,
on a river snowing.

—GEORGE MENDOZA
"On a River Snowing"

It sifts from leaden sieves,
It powders all the wood,
It fills with alabaster wool
The wrinkles of the road.

It makes an even face
Of mountains and of plain,—
Unbroken forehead from the east
Unto the east again.

It reaches to the fence,
It wraps it, rail by rail,
Till it is lost in fleeces;
It flings a crystal veil

On stump and stack and stem,—
The summer's empty room,
Acres of seams where harvest were,
Recordless, but for them.

It ruffles wrists of posts,
As ankles of a queen,—
Then stills its artisans like ghosts,
Denying they have been.

—EMILY DICKINSON
"The Snow"

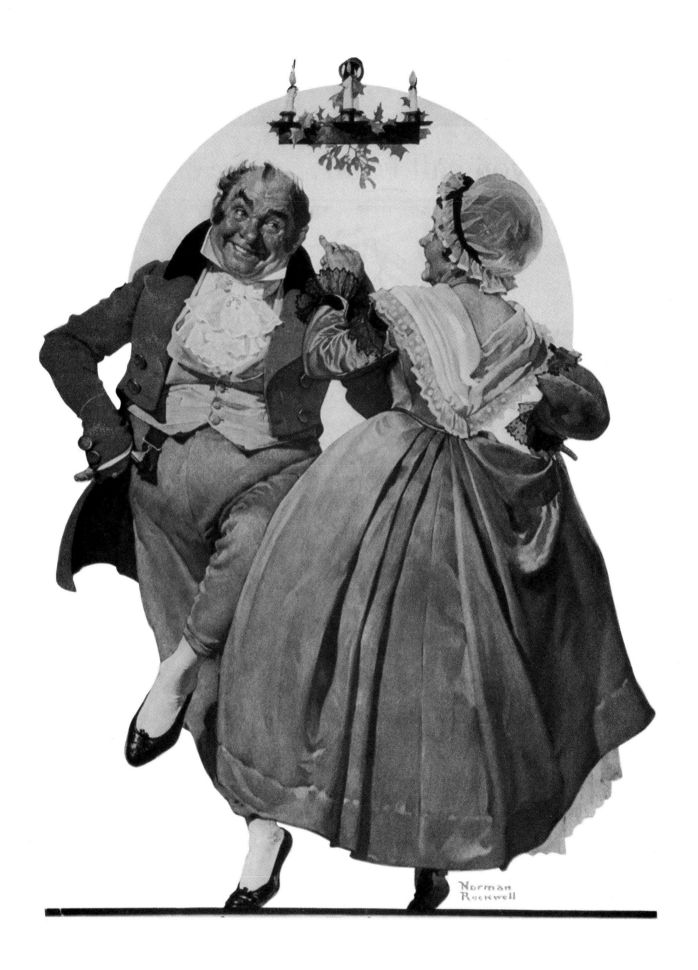

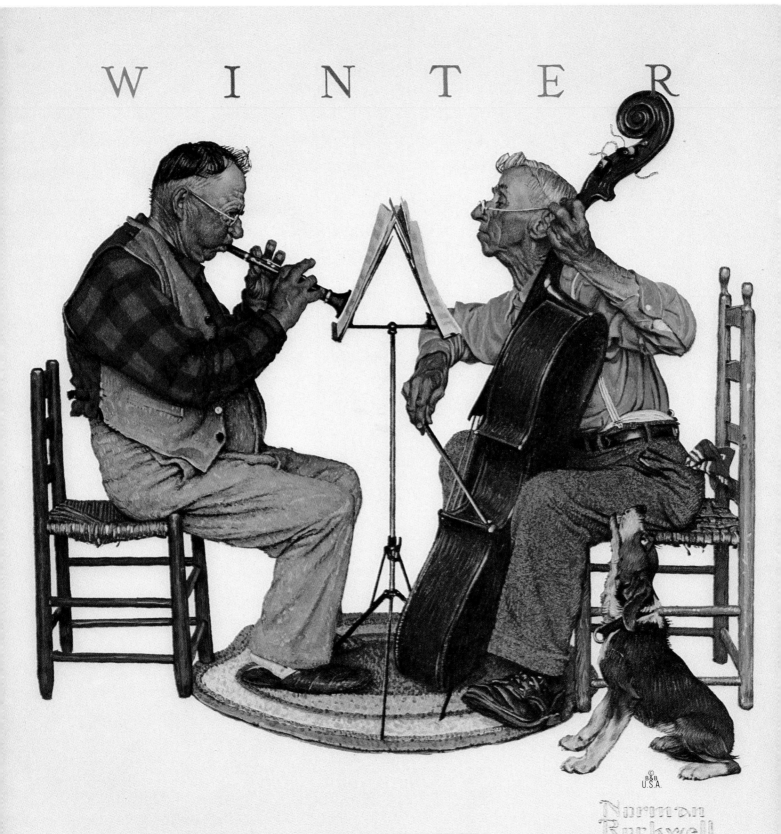

The cemetery stones are walking
in the final shadows of the light,
white beneath the village stars,
tilting away to night.

—*GEORGE MENDOZA*

Outside the wind, outside the wind:
leaves flying from graves
beneath the sheep-nose trees,
field leaves sailing back to derelict boughs
where apples were once planets to be picked.
Now the wind cracks cold
and night stands in the stars
waiting for snow to stick.

—*GEORGE MENDOZA*

The wind's on the wold
 And the night is a-cold,
 And Thames runs chill
'Twixt mead and hill.
But kind and dear
Is the old house here
And my heart is warm
Midst winter's harm.
Rest then and rest,
And think of the best
'Twixt summer and spring,
When all birds sing
In the town of the tree,
And ye lie in me
And scarce dare move,
Lest the earth and its love
Should fade away
Ere the full of the day.
I am old and have seen
Many things that have been:
Both grief and peace
And wane and increase.
No tale I tell
Of ill or well,
But this I say:
Night treadeth on day,
And for worst or best
Right good is rest.

—WILLIAM MORRIS
"Inscription for an Old Bed"

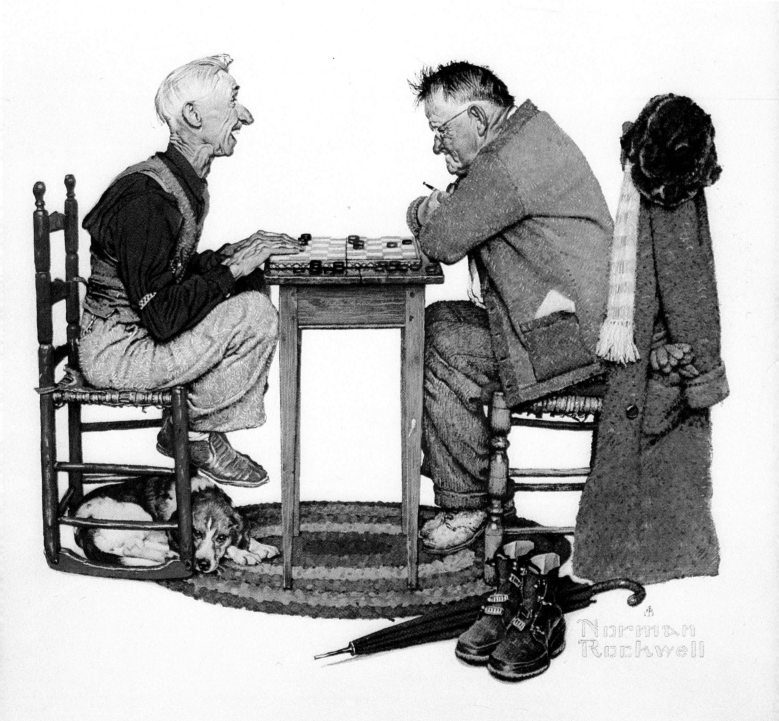

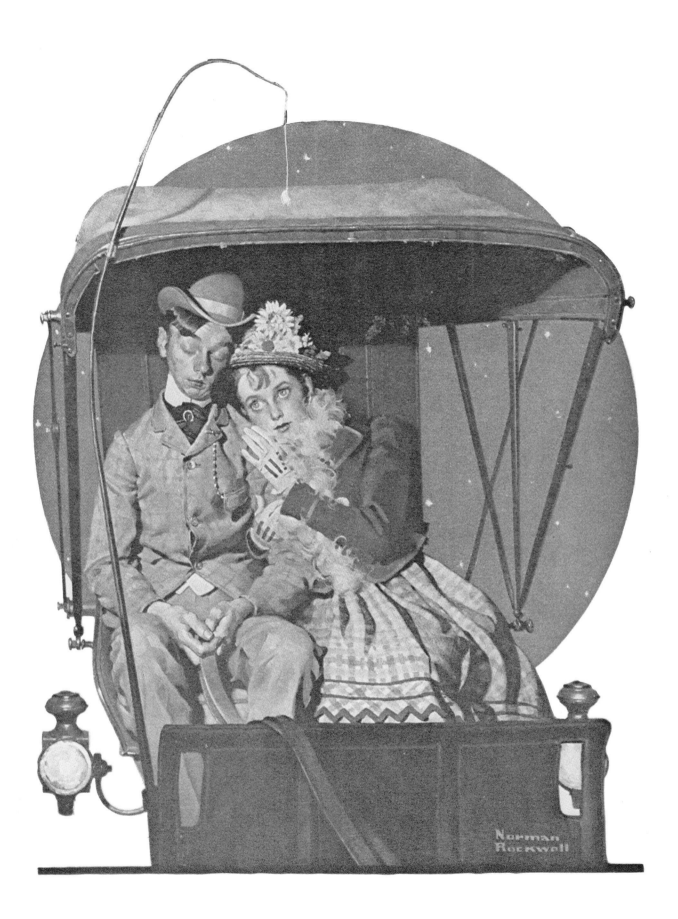

Behind me is a field
of smoke grass.
There are holes in the trees.
Open mouths of mist smoke.
Who sets fires in the dry wood?
The blue trees tremble,
the orange butterfly crackles in flame.
I am placed upon a shelf of time
when winter is coming . . .
and things go dying.

—GEORGE MENDOZA

little finch
when will you come
and eat the bread
I've placed upon the balcony
for you?
when, little finch,
will you fly down
and startle the world
to let me know you are hungry,
full of hunger,
frail in your winter fly . . .
when, little finch, when
will your feathers brush aside
my long waiting?
If you do not eat, little finch,
then why must I?

—GEORGE MENDOZA

The way of love was thus.
He was born one winter morn
With hands delicious,
And it was well with us.

Love came our quiet way,
Lit pride in us, and died in us,
All in a winter's day.
There is no more to say.

—RUPERT BROOKE
"Song"

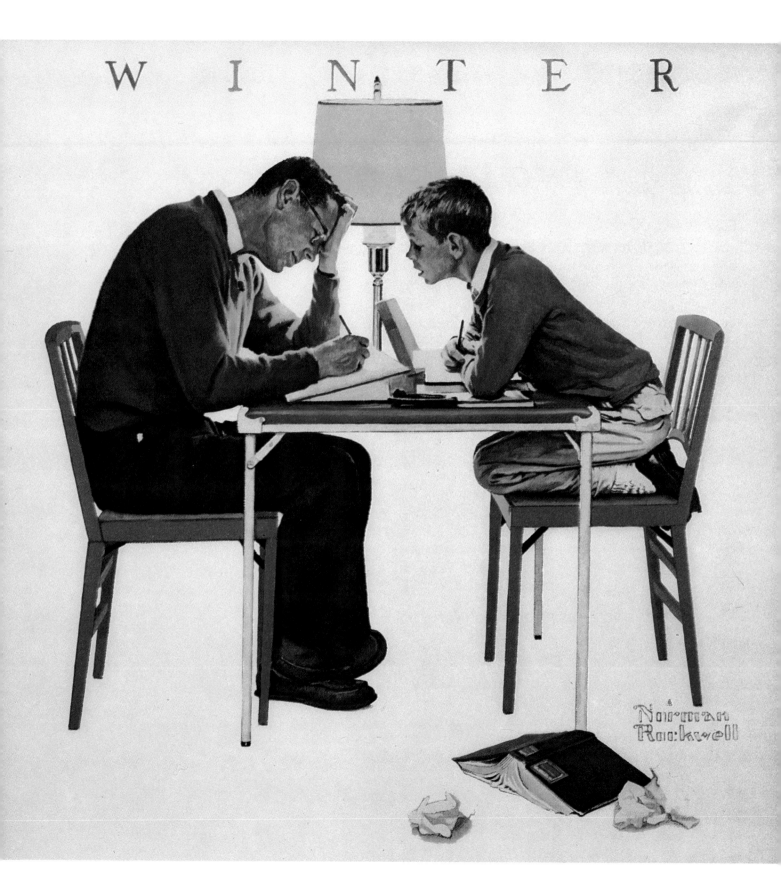

Blow, blow, thou winter wind,
Thou art not so unkind
 As man's ingratitude;
Thy tooth is not so keen,
Because thou art not seen,
 Although thy breath be rude.
Heigh-ho! sing, heigh-ho! unto the green
 holly:
Most friendship is feigning, most loving mere
 folly:
 Then, heigh-ho, the holly!
 This life is most jolly.

Freeze, freeze, thou bitter sky,
That dost not bite so nigh
 As benefits forgot:
Though thou the waters warp,
Thy sting is not so sharp
 As friends remember'd not.
Heigh-ho! sing, heigh-ho! unto the green
 holly:
Most friendship is feigning, most loving mere
 folly:
 Then, heigh-ho, the holly!
 This life is most jolly.

—WILLIAM SHAKESPEARE
"Blow, Blow, Thou Winter Wind"

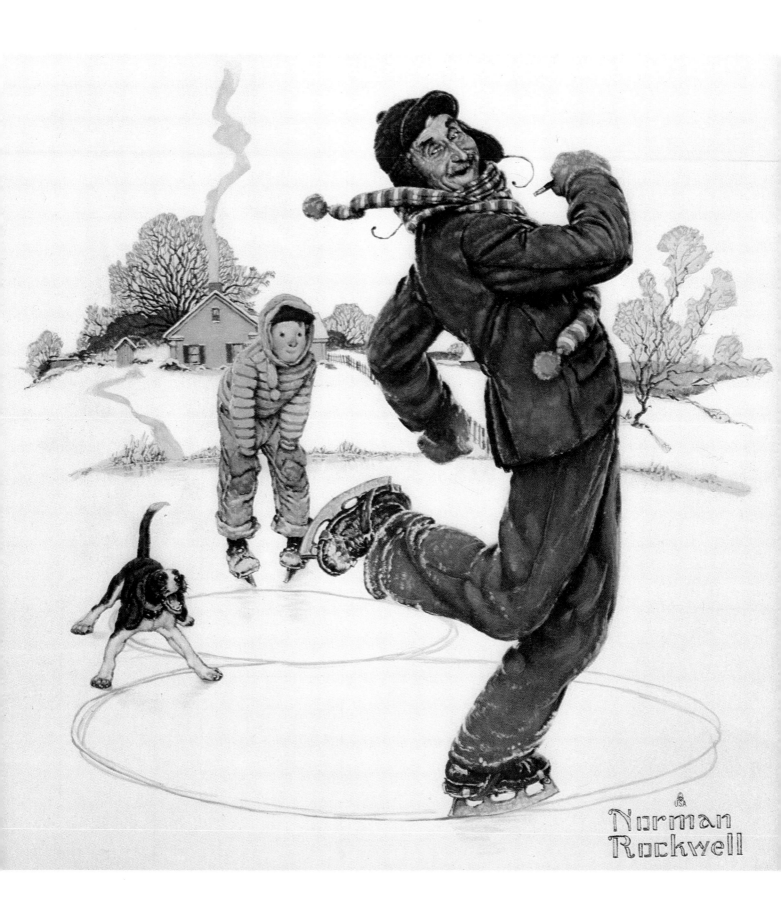

Norman Rockwell

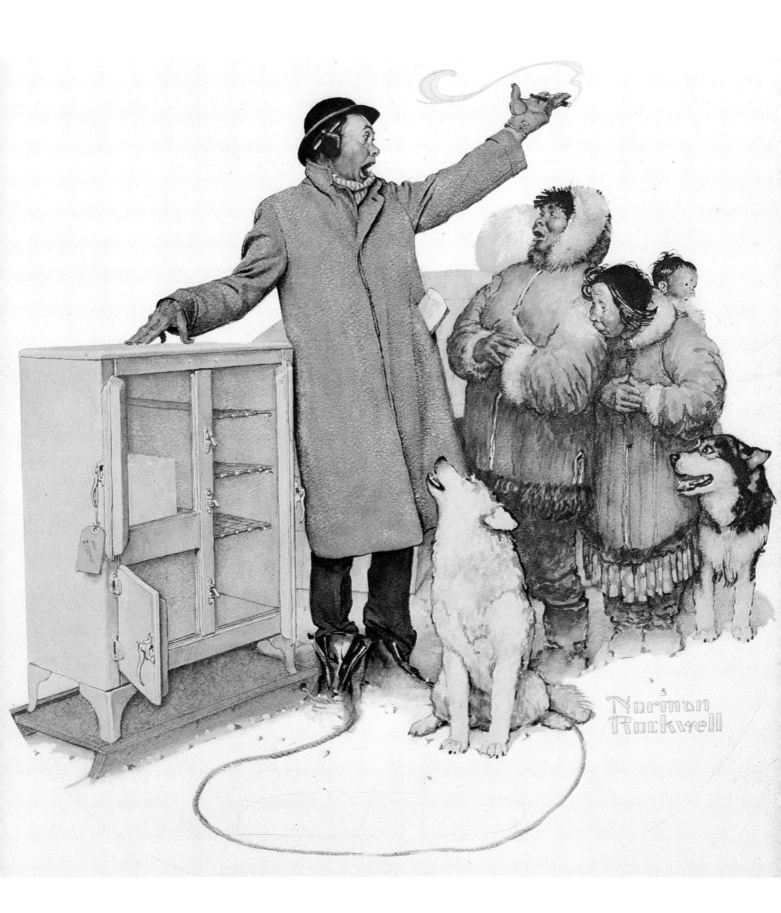

Whose woods these are I think I know.
His house is in the village though;
He will not see me stopping here
To watch his woods fill up with snow.

My little horse must think it queer
To stop without a farmhouse near
Between the woods and frozen lake
The darkest evening of the year.

He gives his harness bells a shake
To ask if there is some mistake.
The only other sound's the sweep
Of easy wind and downy flake.

The woods are lovely, dark and deep.
But I have promises to keep,
And miles to go before I sleep,
And miles to go before I sleep.

—ROBERT FROST
"Stopping by Woods on a Snowy Evening"

Take off your cloak and your hat
And your shoes, and draw up at my hearth
Where never woman sat.

I have made the fire up bright;
Let us leave the rest in the dark
And sit by firelight.

The wine is warm in the hearth;
The flickers come and go.
I will warm your limbs with kisses
Until they glow.

—D. H. LAWRENCE
"December Night"

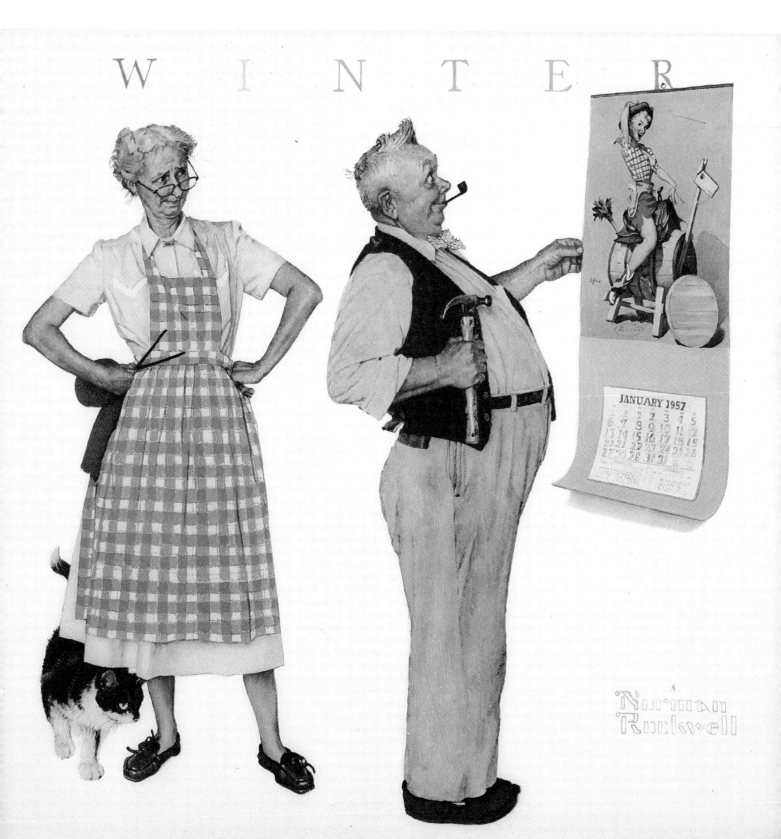

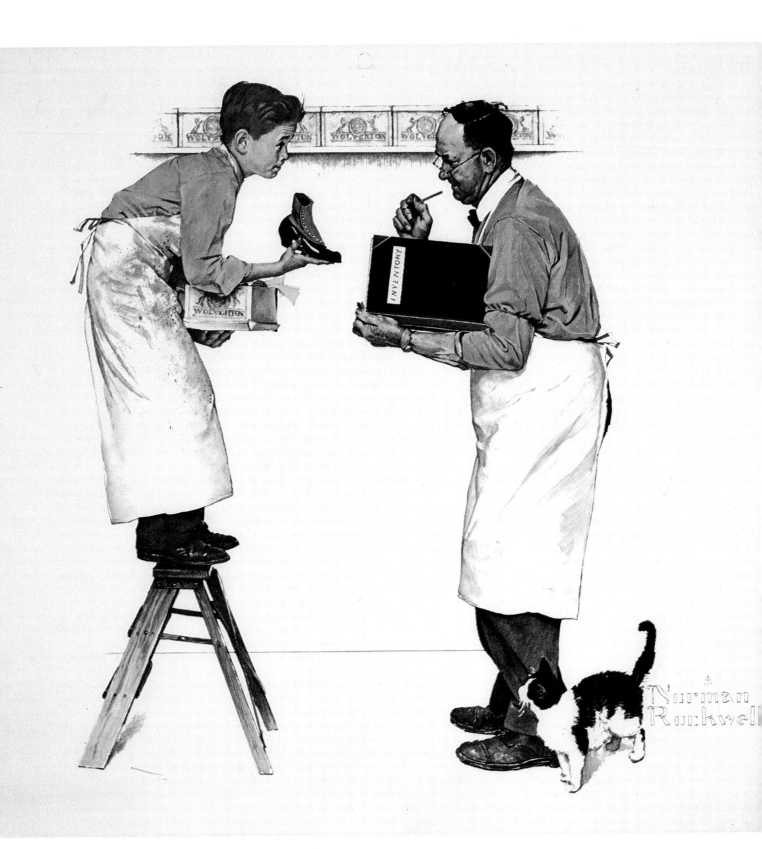

Let us walk in the white snow
 In a soundless space;
With footsteps quiet and slow,
 At a tranquil pace,
Under veils of white lace.

I shall go shod in silk,
 And you in wool,
White as white cow's milk,
 More beautiful
 Than breast of gull.

We shall walk through the still town
 In a windless peace;
We shall step upon white down,
 Upon silver fleece,
 Upon softer than these.

We shall walk in velvet shoes:
 Wherever we go
Silence will fall like dews
 On white silence below.
 We shall walk in the snow.

—ELINOR WYLIE
"Velvet Shoes"

Snow on the wood
cut for the fire
 snow on the wood
to burn my desire
 snow in the fields
stars and night
 and winterwood
cut for the fire

—GEORGE MENDOZA

Tis a dull sight
 To see the year dying,
 When winter winds
Set the yellow wood sighing:
Sighing, O sighing!

When such a time cometh
 I do retire
 Into an old room
Beside a bright fire:
O, pile a bright fire!

—EDWARD FITZGERALD
"Old Song"

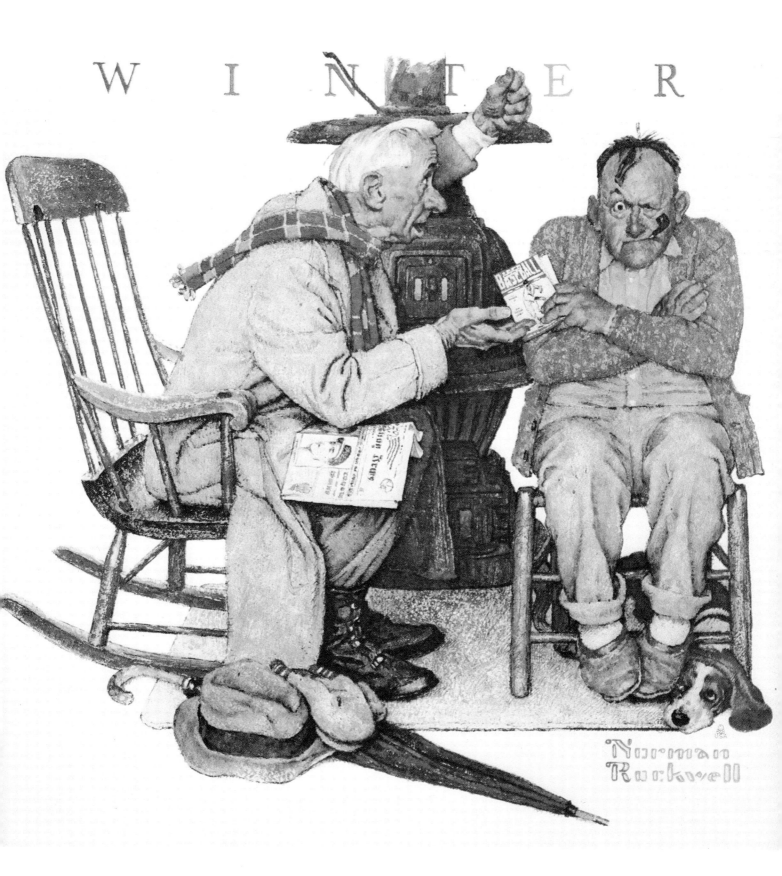

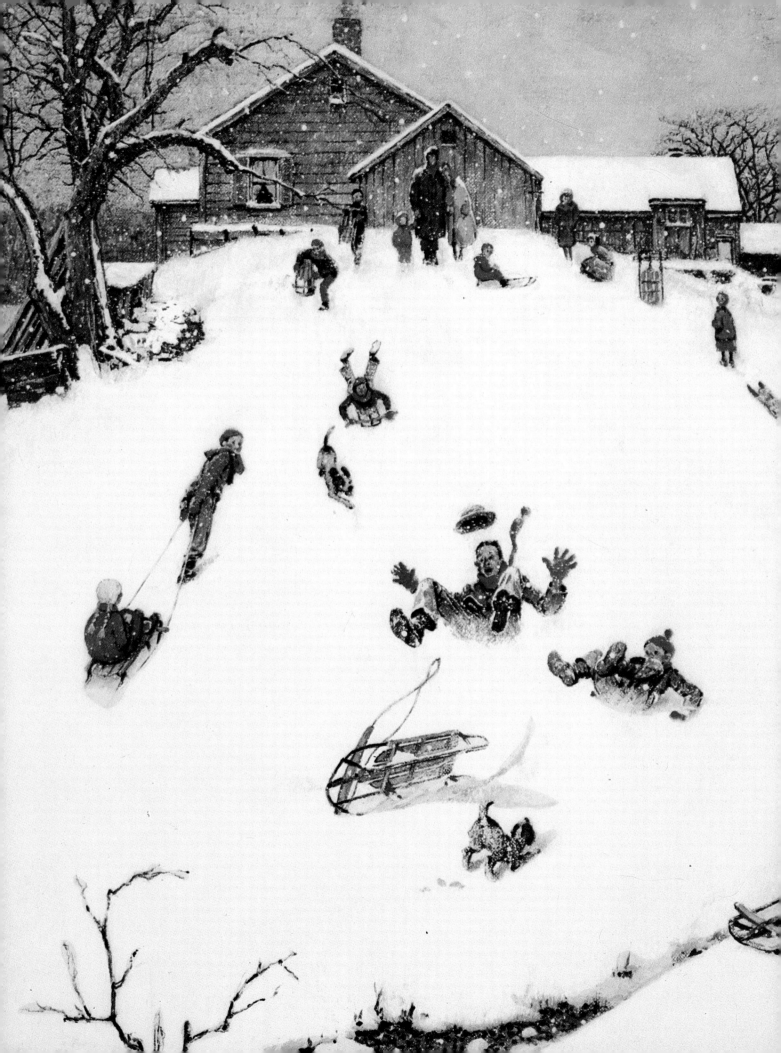

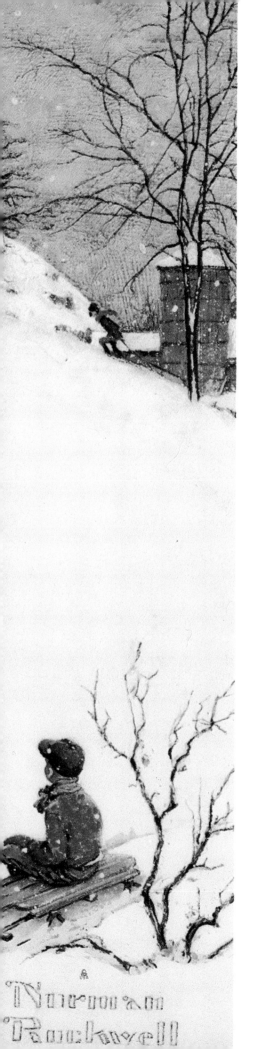

"Going home," said the wind
as it sailed like a storm
by and by.

"Where?" said I.

"Through the stars,
through the pine,
across the lonely fields
mantled with snow,
beyond stony fields
and rivers night-frozen.
Going home," said the wind.

"I know a child just like
you," I howled back at the wind.
"Afraid of nothing. Thinks he can
wear the world on his finger
like a thimble."

"Then he's listening to me," said
the wind, "as I swirl through the night-deep,
going home."

—GEORGE MENDOZA
"Going home, said the wind"

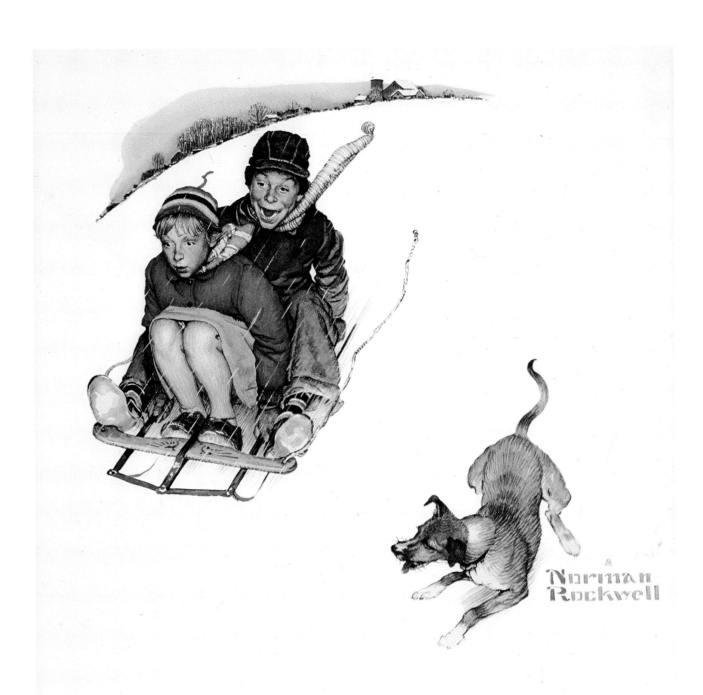

High the hill
that sees the world
through stars and snow.
Crackling sky, here I stand
against earth's wintered tree.

"Open your cafe, sky!"
Your moon will be my table round
and your stars my lanterns
to sparkle upon my wine.
Drink. They're strangers
here who ask for more.
I know them not,
yet they tell me stories
I've heard before.

At my feet a child's swing
shifts in the icy air.
No one there.
Cafe sky never so lonely
as here.

—GEORGE MENDOZA
"Open your cafe, sky"

The way a crow
Shook down on me
The dust of snow
From a hemlock tree

Has given my heart
A change of mood
And saved some part
Of a day I had rued.

—ROBERT FROST
"Dust of Snow"

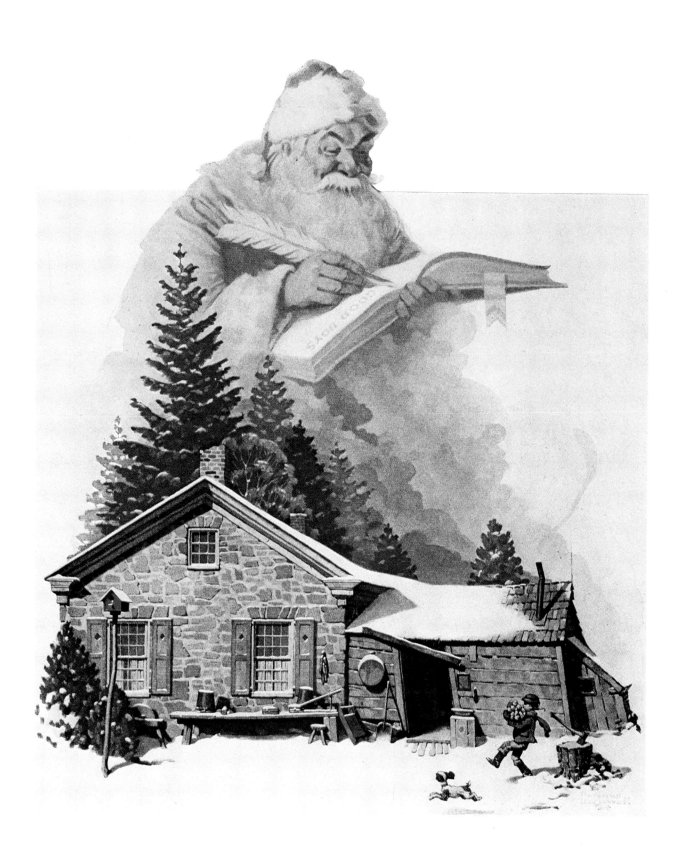

In a drear-nighted December,
 Too happy, happy tree,
Thy branches ne'er remember
 Their green felicity:
The north cannot undo them,
With a sleety whistle through them;
Nor frozen thawings glue them
 From budding at the prime.

In a drear-nighted December,
 Too happy, happy brook,
Thy bubblings ne'er remember
 Apollo's summer look;
But with a sweet forgetting,
They stay their crystal fretting,
Never, never petting
 About the frozen time.

Ah! would 'twere so with many
 A gentle girl and boy!
But were there ever any
 Writhed not at passèd joy?
To know the change and feel it,
When there is none to heal it,
Nor numbèd sense to steal it,
 Was never said in rhyme.

—JOHN KEATS
"Stanzas"

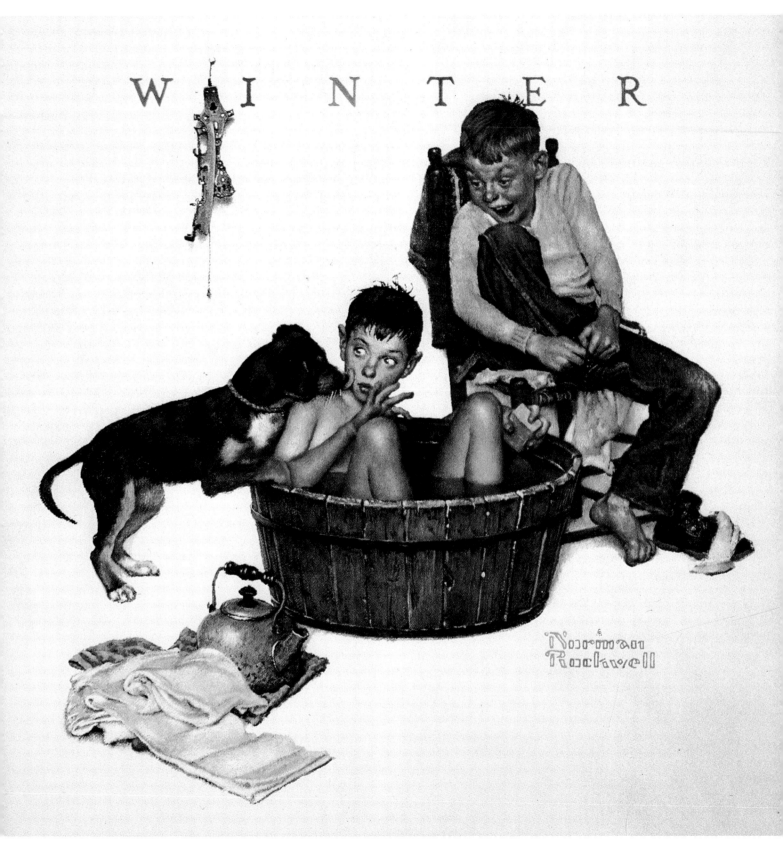

Now winter downs the dying of the year,
And night is all a settlement of snow;
From the soft street the rooms of houses show
A gathered light, a shapen atmosphere,
Like frozen-over lakes whose ice is thin
And still allows some stirring down within.

I've known the wind by water banks to shake
The late leaves down, which frozen where
 they fell
And held in ice as dancers in a spell
Fluttered all winter long into a lake;
Graved on the dark in gestures of descent,
They seemed their own most perfect
 monument.

There was perfection in the death of ferns
Which laid their fragile cheeks against the
 stone
A million years. Great mammoths overthrown
Composedly have made their long sojourns,
Like palaces of patience, in the gray
And changeless lands of ice. And at Pompeii

The little dog lay curled and did not rise
But slept the deeper as the ashes rose
And found the people incomplete, and froze
The random hands, the loose unready eyes
Of men expecting yet another sun
To do the shapely thing they had not done.

These sudden ends of time must give us
 pause.
We fray into the future, rarely wrought
Save in the tapestries of afterthought.
More time, more time. Barrages of applause
Come muffled from a buried radio.
The New-year bells are wrangling with the
 snow.

—RICHARD WILBUR
"Year's-End"

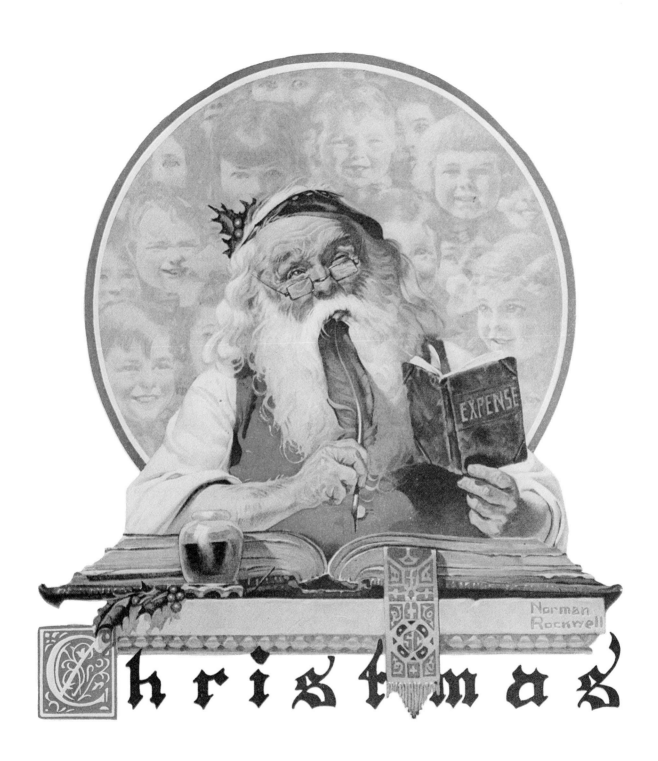

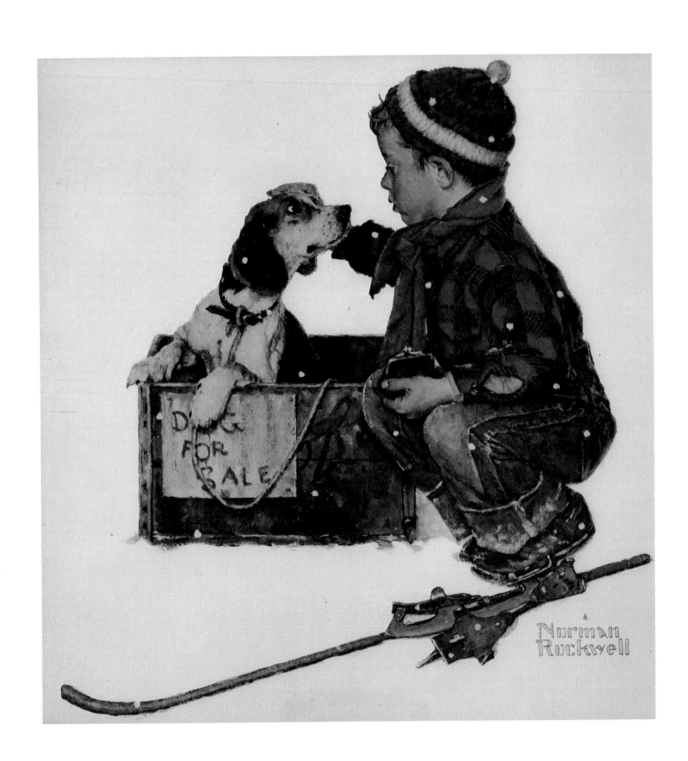

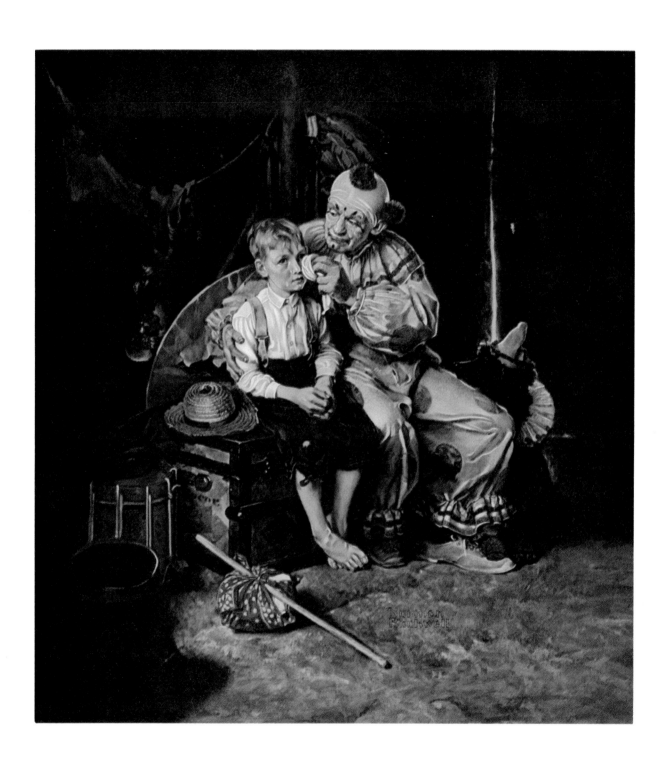